LEGENDARY L(

— OF —

# FORT WORTH

## TEXAS

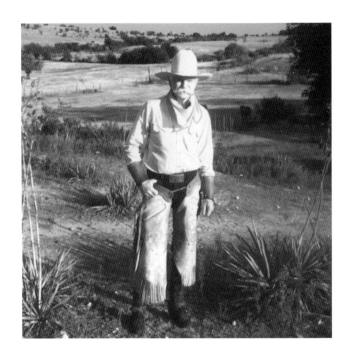

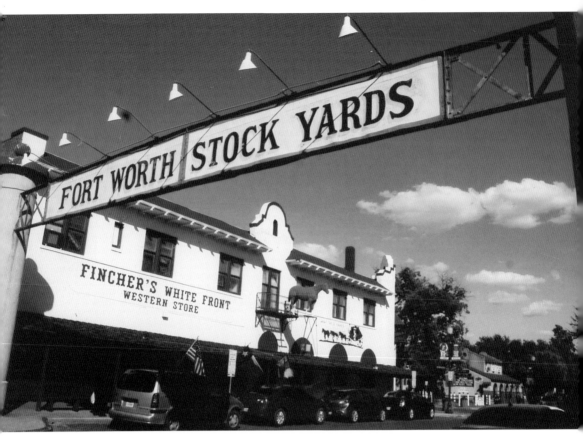

**Fort Worth Stockyards**

The Fort Worth Stockyards symbolize the heart of the city and its people. History and tradition mixed with modern amenities and ideas make the stockyards the perfect place to sneak a peek at what makes "Cowtown" so wonderful. Commerce, good food, the arts, and interesting, unique characters fill the stockyards' streets; it is everything Fort Worth folks enjoy most. (Courtesy of Joan Kurkowski-Gillen.)

**Page 1: Steve Murrin**

Steve Murrin is a modern cowboy with a penchant for the past. A preservationist, who owns buildings and land in the Fort Worth Stockyards, he is known for his trademark ten-gallon hats, white hair, and long handlebar mustache. Murrin is a visionary who saw tourists where cattle once roamed. The businessman bought dilapidated properties and repurposed them into restaurants and shops that reflect Cowtown's Western heritage and celebrate its place in history. (Courtesy of Sasha Camacho.)

LEGENDARY LOCALS

OF

# FORT WORTH

TEXAS

EMILY WHITE YOUREE
AND JOAN KURKOWSKI-GILLEN

LEGENDARY
LOCALS

Legendary Locals is an imprint of Arcadia Publishing
Charleston, South Carolina

Printed in the United States of America

Library of Congress Control Number: 2013948433

For all general information, please contact Arcadia Publishing:
Telephone 843-853-2070
Fax 843-853-0044
E-mail sales@arcadiapublishing.com
For customer service and orders:
Toll-Free 1-888-313-2665

Visit us on the Internet at www.arcadiapublishing.com

**Dedication**
*To the always fascinating and never tiring Cowtown citizens—past and present—you are the epitome of gusto, grace, and goodwill.*

**On the Front Cover:** Clockwise from top left:
Sr. Frances Evans and Sr. Maggie Hession, Texas Rangers fans (Courtesy of John F. Rhodes, *Dallas Morning News*; see page 75), Amanda Bush, lawyer (Courtesy of Jackson Walker, LLP; see page 40), Manuel Jara, civic leader (Courtesy of JoLinda Martinez; see page 56), Bob Lilly, football player (Courtesy of Special Collections, Texas Christian University; see page 74), Stephen Seleny, educator (Courtesy of Trinity Valley School; see page 65), Natalie Brackett, lawyer (Courtesy of Shannon, Gracey, Ratliff & Miller, LLP; see page 38), Gary Patterson, coach (Courtesy of Special Collections, Texas Christian University; see page 74), Claude Platte, Tuskegee airman (Courtesy of Erma Platte; see page 47), Tiffin Hall, entrepreneur (Courtesy of Kevin Guyton; see page 88).

**On the Back Cover:** From left to right:
Edna Gladney, adoption activist (Courtesy of Gladney Center for Adoption; see page 59), Pappy O'Daniel, entertainer and politician (Courtesy of Texas State Library & Archives Commission; see page 32).

# CONTENTS

# ACKNOWLEDGMENTS

**Emily White Youree:** Many thanks to the Tarrant County Medical Society, Cathy Spitzenberger (University of Texas at Arlington Library), John Anderson (Texas State Library), and the numerous individuals who provided biographical information and photographs to a gal hoping to capture a snippet of Cowtown's spirit. Thank you for fielding phone calls, returning e-mails, researching facts, scanning photographs, granting interviews, and making my job a joy.

To my partner in crime, Joan Kurkowski-Gillen, we did it! What a treat and inspiration to watch you exert your journalistic acumen. I am so thrilled to call you friend.

And to those who kept my life afloat during writing binges and multiple appointments, especially to Lisa Carpenter—how can I ever thank you? Much appreciation goes to my family and friends who supported and encouraged me from proposal to print. Bryan and Anna Zane, you have my whole heart. Finally, praise goes to my great God who gave me passion for the pen and grace to pursue my dreams.

**Joan Kurkowski-Gillen:** Everyone has a story to tell, and I've enjoyed sharing the personal histories of the people who make Fort Worth a special place to live. A stranger, who is now my friend, invited me into this book project; Emily White Youree, your encouragement and expertise guided me through the process, and I am eternally grateful.

Special thanks to Sr. Louise Smith, SSMN; Jim Lane; Doug Sutherland; Kathy Shaw; Kevin Foster; Fr. David Bristow; Michael Barks; Tom and Karen Williams; Lauren Deutsch; and other kind people who went out of their way to provide photographs or advice. I would like to express appreciation and love to my husband, Kevin, and children, Ryan, Caitlin, Conor, Mac, and Devin for their unwavering support. To my parents, Arthur and Eleanor Kurkowski, thank you for sacrificing to give me the best education possible.

And finally, to Tom Steinert-Threlkeld, my former employer, who led this typewriter-schooled journalist into the computer age—may you rest in peace.

# INTRODUCTION

What makes Fort Worth so interesting and unforgettable? It's not only the Horned Frog chants bellowing from the TCU stadium or the echo of applause from Bass Hall. It's not the roar of the rodeo crowd at Cowtown Coliseum or the admiring look of visitors as they stroll through galleries colored with artwork by Remington, Monet, and Warhol.

It's true. Cowtown boasts top-notch museums, competitive athletics, and award-winning restaurants. But it's not the places that define Fort Worth or create the city's distinct "cowboy and culture" lifestyle. It's the people.

Since its beginnings in 1849 as an Army outpost, the folks who call Fort Worth home—and those who only stayed for a while—shaped the city's unique character: Soldiers and opportunists, railroad executives and entrepreneurs, meatpackers and restaurateurs, cowboys and outlaws, surgeons and professors, champions and villains. These are the people who molded Fort Worth into a city respected for its thriving industries, diversity, and down-home charm.

The following pages feature a sampling of Fort Worth's characters—from the notorious to the unsung to the inspiring. For example, Dr. R. Joseph "Joe" White (see page 18) displayed ingenuity and a call for excellence as one of the first trained surgeons in town. His decades-long career influenced the evolution of the medical district from Wild West practices to professional, progressive medicine.

Khleber Miller Van Zandt (see pages 12, 13) arrived in Fort Worth after fighting in the Civil War and started a school before becoming involved in railroad construction and the banking business. Reminders of his pioneering work and influence are still seen.

Debra Lehrmann (see page 31) served Tarrant County as lawyer and judge, making strides in family law and the representation of children, and then proceeded to preside as a justice of the Supreme Court of Texas.

Long before Lehrmann's time, Mordecai Hurdleston (see page 29) reformed the Fort Worth Police Department. During his brief tenure as police commissioner, officers adopted the eight-hour work shift and began thinking of themselves as public servants.

Or consider Dr. Daniel Barbaro (see page 49), who dove into the HIV/AIDS developments of the 1980s, participating in clinical trials and sounding the rally cry to improve patient care and awareness. These initially controversial practices showed a burgeoning medical community and evolving society the importance and value of every person. His medical practice, as well as others, improved the medicines, care, life expectancy, and overall well-being of HIV patients.

While health professionals battled disease in the United States, men like Robert "Pearcy" Purcell (see page 46) and John Yuill (see page 45) fought for their country's interests abroad. Both Air Force pilots weathered the brutality of a prisoner of war (POW) camp when their planes were shot down during the Vietnam War.

Back home, those who frequent the Paris Coffee Shop know owner Mike Smith (see page 90) as the gentleman ready to greet them at the front door with a warm handshake. Harold Taft Jr. (see page 71), the longtime, beloved KXAS-TV weatherman, had that same affable quality. The trusted meteorologist was a welcomed fixture in homes across North Texas as families watched the evening news.

Paul Perrone and Horace Park (see page 99) built one of the few independent pharmacies still in existence in Fort Worth. From the soda fountain and ice cream days to the complexities of insurance and pharmacology, the Perrone Pharmacy remains a dependable source for quality customer service and knowledgeable pharmacists. Since 1952, this establishment provided employment to locals and bolstered the Cowtown economy. And when it comes to innovation, who is more clever than Theo

Yordanoff (see page 93)? The restaurateur turned calf testicles into a "calf fries," a delicacy still served to customers in the stockyards.

In true Texas style, Red Steagall (see page 109) dedicated his life to cowboy culture and folklore through storytelling and songwriting. Since 1991, he has hosted the Red Steagall Cowboy Gathering in the Fort Worth Stockyards. This event draws thousands of artisans, musicians, and cowboy enthusiasts each year. Not only does this award-winning artist bring his own work to Cowtown (and the world), but he also encourages others to enhance and preserve the history and culture of the Texas cowboy.

Sweetie Ladd (see page 121) preserved the history of her adopted hometown with an easel and palette. Drawing inspiration from old photographs, the elderly painter used her primitive "Grandma Moses" style to recreate scenes from yesteryear. Collectors still covet her work.

For every person highlighted in this project, dozens more could be—and should be—included. An encyclopedia could not contain the stories that make the founding and continued growth of Fort Worth legendary. People of all shapes and sizes, skill sets and statuses, are the true grit that makes Cowtown great.

# CHAPTER ONE

# Pioneers

What exudes the pioneer spirit more than a can-do attitude, a hankering for adventure, and the courage to brave the unknown? That definition aptly describes the folks featured in this chapter.

Fort Worth may never have achieved its potential if it were not for Capt. B.B. Paddock who published his Tarantula railroad map in 1873. The crude drawing showed nine railroad lines, radiating like the spokes of a wheel, from Fort Worth. The city was not a railroad destination at the time, but newspaper editor B.B. Paddock's vision and promotion enticed the Texas & Pacific (T&P) Railroad to lay track. The pioneering spirit of contemporaries like Maj. K.M. Van Zandt, E.M. Daggett, and others, who gave the railroad company land to ensure construction, helped Paddock's efforts.

People came on wagons and horseback to watch the first T&P train pull into the station on July 19, 1876. Other rail companies followed, and Fort Worth soon became a booming hub of commerce and cattle. The frontier town was no longer just a way station along the cattle trail. It was the end of the drive where cattle was herded into pens, slaughtered, and shipped to consumers across the country.

Fort Worth was now a livestock center, and Cowtown was born.

Only a few years before, in 1869, the Clark brothers arrived in Fort Worth with the training and philosophy to influence education. From their labors came the collegiate establishment later known as Texas Christian University (TCU).

On the medical front, significant strides were made in Fort Worth during the early 1900s. Dr. May Owen—a pioneer pathologist—contributed considerable discoveries to science and opened the door for future female practitioners in the town.

Pioneers paved the way for others to thrive. Thanks to these trailblazers and their leadership in public service, medicine, entertainment, and community outreach, Fort Worth is now consistently ranked as one of "America's Most Livable Cities."

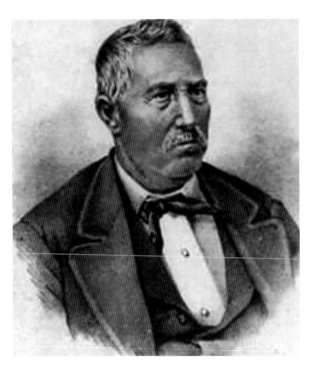

**E.M. Daggett**
E.M. Daggett's foresight helped Fort Worth grow. The pioneer, who settled here in 1854, is credited with enticing the Texas & Pacific Railroad to route its line through the city by donating 96 acres for the depot and tracks. He also campaigned to make Fort Worth the county seat. His enthusiasm for development prompted newspaper editor B.B. Paddock to call Daggett the "Father of Fort Worth." (Courtesy of T. Williams, *In Old Fort Worth*.)

**Buckley (B.B.) Paddock**
When Buckley (B.B.) Paddock died in 1922, Fort Worth flew its flags at half-mast. The Mississippi resident moved to Fort Worth in 1872 to practice law. Instead, he gained prominence as newspaper publisher of the *Fort Worth Democrat*, served in the Texas Legislature, and was Fort Worth mayor from 1892 to 1900. Using the power of his newspaper, the publisher led a campaign to promote Fort Worth's potential as a rail hub. (Courtesy of T. Williams, *In Old Fort Worth*.)

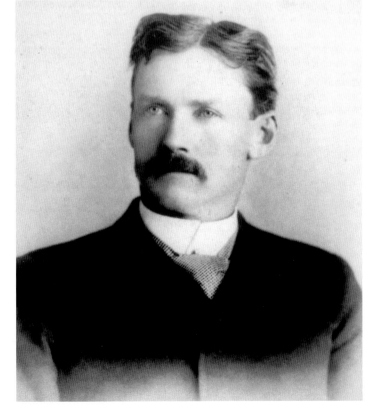

## Jesse Chisholm

Jesse Chisholm blazed a trail for others to follow. The Chisholm Trail, named in his honor, became one of the major cattle-drive routes connecting Texas ranches with Kansas railroad markets. Born of Scottish and Cherokee parents in Tennessee, he grew up in an environment that made him familiar with both Anglo and Native American culture and language. This skill made him a successful frontier trader and useful negotiator/interpreter for the US government eager for treaties with Indian tribes in Texas and Oklahoma. Fort Worth's place on the Chisholm Trail helped the city prosper. (Courtesy of Oklahoma Historical Society.)

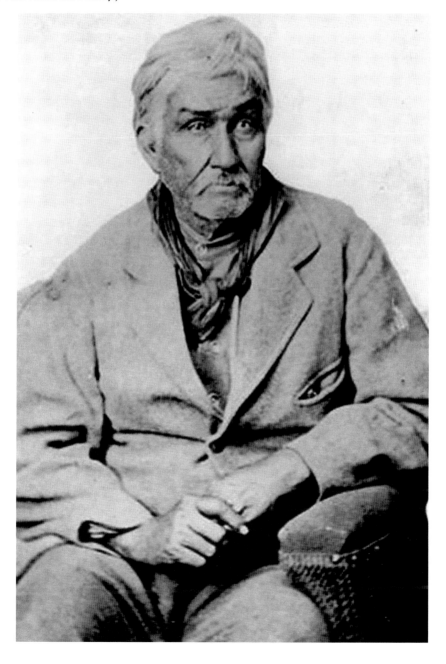

### Khleber Miller Van Zandt

When Khleber Miller (K.M.) Van Zandt arrived in Fort Worth after fighting in the Civil War, he described his new hometown as "sad and gloomy." The industrious go-getter immediately set out to change the desolate town. He began a successful dry good business that gave him the capital to invest in other ventures.

Van Zandt's construction company helped grade the land for 30 miles of Texas & Pacific Railroad track from Fort Worth to Dallas. Along with other partners, he founded a company that was the forerunner of the Fort Worth National Bank and remained president of the bank until his death. The pioneer also cofounded the *Fort Worth Democrat*, the town's first newspaper, and helped start the first post–Civil War school in the area. He served in the state legislature in 1873–1874 but abandoned any political aspirations in favor of civic interests. Locally, Van Zandt served as city treasurer, city councilman, and park board commissioner.

He was married three times and had 14 children. Many of his offspring became city leaders and prominent professionals.

By the time of his death in 1930 at the age of 93, Fort Worth was becoming a major center for commerce and industry. (Courtesy of Edmund Cranz.)

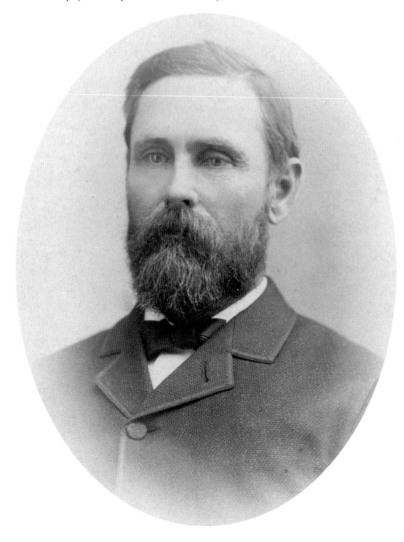

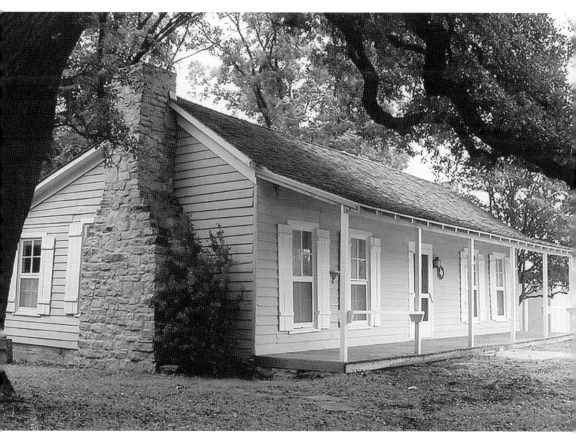

**Van Zandt Cottage**
The K.M. Van Zandt Cottage is the oldest Fort Worth home on its original foundation. Restored with wood siding and other improvements, the structure is a Texas landmark and was added to the National Register of Historic Places in 2012. The Van Zandt Cottage is owned by the City of Fort Worth's Parks and Community Services Department and is operated by Log Cabin Village. (Courtesy of City of Fort Worth Log Cabin Village.)

### Ripley Arnold

On June 6, 1849, Maj. Ripley Arnold and Company F of the 2nd Dragoons established a military post on a bluff overlooking the Trinity River. He named the site in honor of Gen. William J. Worth, the commander he served under during the Mexican-American War.

Established to protect settlers in the area, the outpost became known as Fort Worth and was the most northern of a string of forts in Central Texas. When troops left Fort Worth for other assignments, pioneers moved into the abandoned buildings. These early residents and their homes became the nucleus for the city of Fort Worth.

Killed in 1853 during a duel, Arnold's body was buried in Fort Graham but was returned to Fort Worth for a second burial in Pioneers Rest Cemetery. (Courtesy of Trinity River Vision Authority.)

### The Clark Brothers

Addison Clark (left) and his younger brother Randolph Clark (right), both volunteer soldiers with the Confederate army, settled in Fort Worth to oversee the Male and Female Seminary, a school associated with the Disciples of Christ denomination. However, just a few years after their arrival in 1869, the raucous behavior of Hell's Half Acre caused the brothers to transition to Thorp Springs where they started the Add-Ran Male and Female College in 1873. The elder Clark served as president while the younger worked as vice president and professor. Due to mounting overhead costs, the Clarks deeded the school to the Disciples of Christ. During the course of history, the institution changed its name to Texas Christian University. In 1895, the college moved to Waco, but it came home to Cowtown in 1910. Both brothers were ministers as well, with Addison pastoring churches and Randolph serving as the Texas Senate chaplain. (Both courtesy of Special Collections, Texas Christian University.)

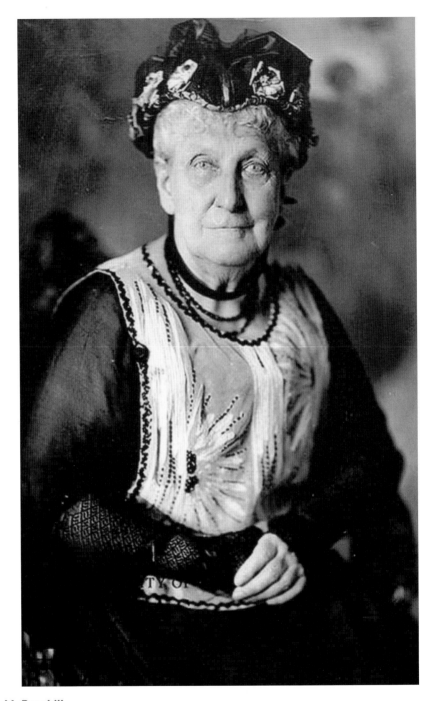

**Belle M. Burchill**
As postmaster, Belle Burchill started home mail delivery in Fort Worth on October 1, 1884. The city had a population of 5,000 at the time and was still considered a frontier community. To launch the new delivery system, Burchill hired five letter carriers in addition to the eight employees already working at the post office. Receiving mail at home was an immediate success. (Courtesy of T. Williams, *In Old Fort Worth.*)

**Jennie Scott Scheuber**
Students, researchers, and book lovers have Jennie Scott Scheuber to thank for the public library system in Fort Worth. The civic leader, who later became active in the women's suffrage movement, organized the first "library boosters" meeting in her home. With a $50,000 Carnegie Foundation grant, the city opened its first library in October 1901. Scheuber was named librarian—a post she held for 37 years. (Courtesy of Joan Kurkowski-Gillen.)

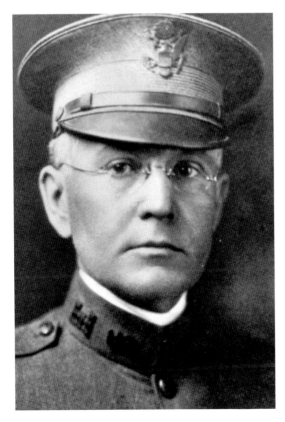

**John B. Hawley**
John B. Hawley was a young scientist and engineer from Minnesota who came to Fort Worth in 1891 to supervise construction of the city's municipal water system. When the project was completed in 1892, the founder of the firm Hawley, Freese, and Nichols became the first independent consulting water and sewer engineer in Texas.

The development of public water works in the booming frontier town reduced the spread of typhoid fever and smallpox epidemics. For the rest of his life, Hawley felt responsible for the operation of Fort Worth's water system. (Courtesy of Freese and Nichols.)

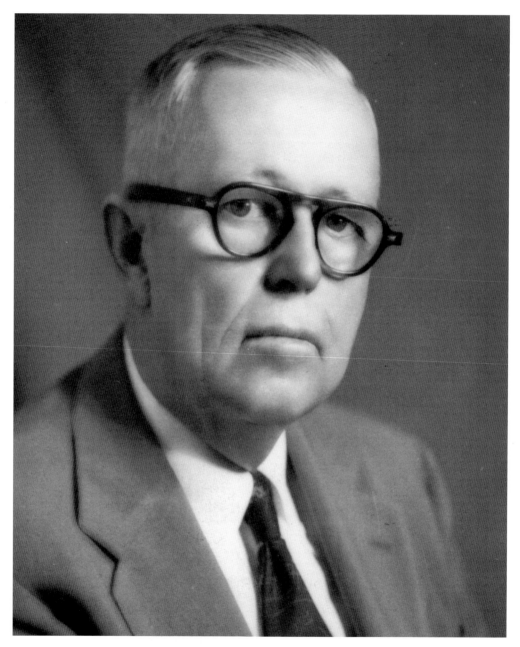

**Dr. R.J. White**

As a teenage boy, R.J. White assisted a local doctor while he performed an on-the-spot amputation of a man's arm. From that moment, Dr. White said, "I had no other thought about how I wanted to spend my life." After attending Yale and Columbia Medical Schools, Dr. White became one of the first trained surgeons in Fort Worth. He held numerous positions, such as the president of the Southern Society of Clinical Surgeons, as well as the Texas Surgical Society. He earned the "Gold-Headed Cane"—the Tarrant County Medical Society's most prestigious honor bestowed annually upon the "doctor's doctor." In 1963, the first R. Joseph White Lectures commenced, a series still committed to oral presentation of outstanding advances in medicine. (Courtesy of Dr. W.S. Lorimer Jr.)

## Dr. May Owen

Born in 1891 to a farming family, May Owen endured a childhood more befitting a male farmhand than an eager, bright girl. Without a family to encourage or support education, Owen graduated from the community primary school in 1904 and spent the next several years tending animals and harvesting crops. Yet, an older brother saw Owen's potential and arranged for her to begin high school through a special program at TCU. She was 21.

During her TCU stint, she landed a job with Dr. Truman C. Terrell, a physician who operated a laboratory. This connection proved serendipitous. The Terrell family, in many ways, became the family Owen needed.

Dr. Terrell provided the additional funding and encouragement Owen needed when she received acceptance into the Louisville Medial School (LMS). True to the medical culture at that time, Owen was the very first female student at LMS and the lone female in her class. After earning her doctorate of medicine degree, Dr. Owen returned to Fort Worth and again joined Dr. Terrell at his laboratories.

As a pathologist, Dr. Owen pursued medical improvements for people and animals alike. She helped develop a rabies vaccine and began testing animals locally (rather than sending specimens to Austin). In 1931, she identified the sugary foods used to fatten sheep contributed to diabetes in the animals, which in turned caused severe sickness or death. This breakthrough propelled her into notoriety in the veterinary circles worldwide.

Dr. Owen also discovered the body could not absorb the talc powder from surgical gloves doctors wore during surgery, explaining why many people experienced scar tissue, adhesions, and infection weeks to months after surgical procedures. Her presentation of "Peritoneal Response to Talc Powder" earned her a standing ovation at the Texas State Medical Association in 1936.

From that point, Dr. Owen continued her success, garnering numerous accolades and commendations (in fact, too numerous to list fully). The Texas Medical Association named her an honorary member for the Women's Auxiliary. The Tarrant County Medical Society elected her as its first female president in 1947 and awarded her the Gold-Headed Cane Award. She presided as the president of the Texas Society of Pathologist, receiving the George T. Caldwell Award. In 1948, she became the "First Lady of Fort Worth" per the Fort Worth Altrusa Club. In 1960, she received appointment to the Governor's Advisory Committee for the Texas Conference on Aging. Dr. Owen was also a catalyst for the Dr. May Owen Hall of Medical Science at the Fort Worth Museum of Science and History. (Courtesy of the Texas Medical Association Archives.)

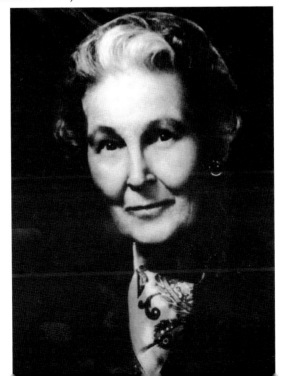

**Dr. Margie Peschel**
When Dr. Margie Peschel graduated from the University of Texas Medical Branch at Galveston in 1952, the survival rate for childhood leukemia was not good. Thanks to research she encouraged, it is now 96 percent.

"That's 100 years of progress and hope in the fight against cancer," says the former president of the Tarrant County branch of the American Cancer Society who received the organization's Lifetime Achievement Award in 2008. (Courtesy of the Texas Medical Association Archives.)

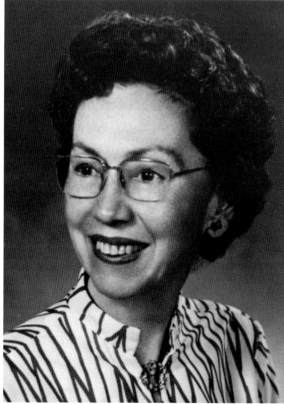

**Dr. Catherine Kenney Carlton**
Dr. Catherine Kenney Carlton spent 64 years serving the Fort Worth community as an osteopathic doctor at the same location—first with her parents and then with her husband, Dr. Elbert Carlton. She was on the original staff of the Fort Worth Osteopathic Medical Center and was named the Physician of the Year for 1997 by the Texas Society of Osteopathic Family Physicians. (Courtesy of University of North Texas Health Science Center Gibson D. Lewis Library.)

**Lenora Rolla**

When Lenora Rolla noticed that African American stories were not part of the country's upcoming bicentennial celebration, she decided to do something about it. An intelligent, respected professional who worked in business management, journalism, and school administration, Rolla helped organize the Tarrant County Black Historical and Genealogical Society in 1977. For 25 years, she gathered volumes of files, photographs, and other materials that are now archived at the Fort Worth Public Library. The restored Lenora Rolla Heritage Center Museum was opened in 2009 and stands as a testament to her dedication and work. (Courtesy of the Tarrant County Black Historical and Genealogical Society.)

### Elizabeth "Betty" Richards Andujar

Elizabeth "Betty" Richards Andujar made political history in 1972 when she was elected the first woman from Tarrant County and first Republican since Reconstruction to the Texas Senate. She represented the 12th District of Texas until her retirement in 1982. Significant legislation she sponsored included a bill requiring county coroners to be qualified pathologists and a bill helping women collect child support. (Courtesy of Texas State Preservation Board.)

### Missy Bonds

Recipient of the 2013 Mitzi Lucas Riley Award, Missy Bonds exemplifies the next generation of cattle ranchers. Daughter of Jo and Pete Bonds, she runs the Bond Ranch's export program and designed a protocol for cattle sold in hormone-free markets. She is the youngest woman elected to the Board of Directors of the Texas and Southwestern Cattle Raisers Association and the first woman elected to a policy leadership position. (Courtesy of April Bonds.)

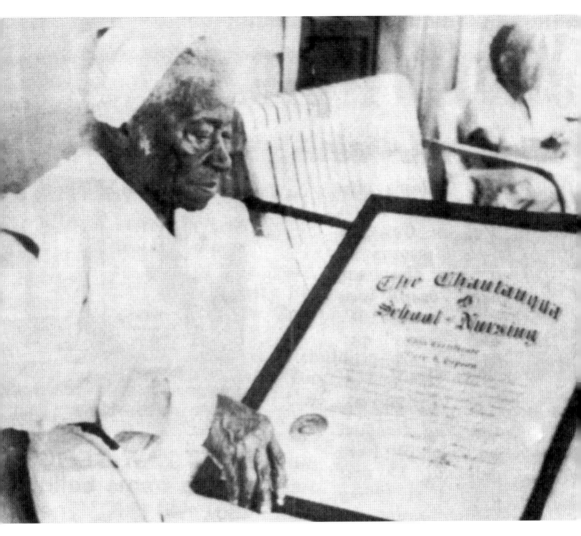

### Mary Keys Gipson

Mary Keys Gipson was born into slavery in Mississippi but that did not stop her from becoming the first African American in Texas to graduate from an accredited nursing school.

At the age of 18, she married Rev. Franklin Pierce Gipson and moved to Fort Worth where she helped organize the South Side Methodist Episcopal Church and served as a midwife to women in her community.

Aware of his wife's interest in nursing, Franklin Gipson encouraged her to enter nursing school. She enrolled in the Chautauqua School of Nursing in Jamestown, New York, and graduated on May 2, 1907, at the age of 53.

After earning her certificate, Gipson assisted some of Fort Worth's preeminent physicians in surgery and obstetrics. A dedicated nurse, she worked until a few years before her death in 1952 at the age of 98. (Courtesy of T. Williams, *In Old Fort Worth*.)

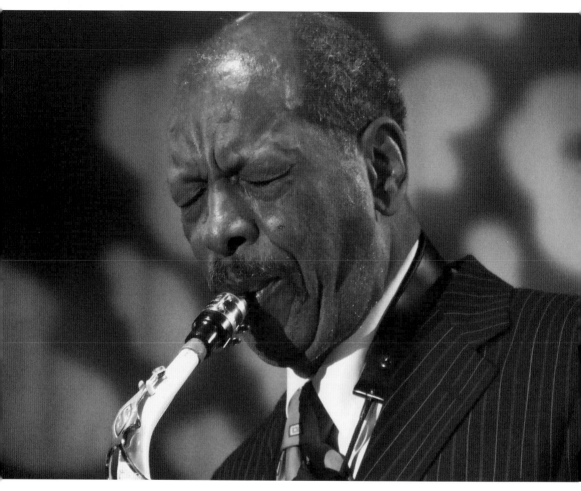

### Ornette Coleman

Ornette Coleman was listening to a band perform at his elementary school when he first heard the saucy sound of a saxophone. It was music the youngster never forgot.

As soon as he was old enough, the Fort Worth native bought his own saxophone and began teaching himself how to play the instrument. He became a working musician while still attending I.M. Terrell High School and developed an improvisational style called "free jazz." His creative, unorthodox approach was controversial but critically acclaimed.

Coleman successfully recorded the albums *Free Jazz* and *The Shape of Jazz to Come* and has composed and performed works for orchestra, string quartet, and various jazz ensembles. In 2007, his album *Sound Grammar* received a Pulitzer Prize for music. Considered a legendary figure in jazz history, Coleman was honored with a Grammy for lifetime achievement. (Courtesy of Lauren Deutsch.)

# CHAPTER TWO

# Marshals and Miscreants

As the livestock and transportation industry grew in Fort Worth, so did the town's red-light district. It did not take long for Hell's Half Acre to gain notoriety. Thanks to gambling, brawling, carousing, and worse, historians dub Cowtown's saloon scene as the unruliest stop on the cattle trails.

The gunfight that killed "Longhair Jim" Courtright outside the White Elephant Saloon still intrigues history buffs of the Old West as well as patrons of the popular bar. Every February 8 at 7:00 p.m., crowds gather on East Exchange Avenue to watch the annual reenactment of the shoot out between city marshal Courtright and renowned gambler Luke Short. An ugly exchange of words between the men ended in the streets outside the saloon with one man dead. Versions of the dual vary, but some say Courtright's gun snagged on the fob of his pocket watch, allowing the challenger standing next to him to discharge a lucky shot.

Disabled and unable to fire his weapon, Courtright did not have a chance. Short got off four more shots killing the local icon. Courtright's popularity earned him one of the largest funerals in Fort Worth history.

Years later, J. Frank Norris, the leading fundamentalist preacher of his day, sparked new controversies as he tried to beat down the vice and violence in Fort Worth's crime district. The colorful, crusading pastor made enemies while leaving his mark on the local culture.

Present-day "good guys" still rally for order and justice in Tarrant County and beyond. Local lawyer Amanda Bush fights to defend against copyright infringement. Ambassador Tom Schieffer worked for decades to improve US relations with other countries.

The battle between the law enforcers and the outlaws will always wage on, even in Fort Worth. But rest assured, the tales from each side prove Cowtown is as provocative as it is protected.

### Luke Short

When Luke Short moved to Fort Worth in 1883, he generated an excitement in the city that "changed the tenor of ordinary happenings."

A professional gambler who kept company with Bat Masterson and Wyatt Earp, Short always kept a handgun in a leather-lined inner pocket. On the night of February 8, 1887, he used it.

Owner of the gambling concession at the White Elephant Saloon, the card wizard enjoyed a genteel clientele. Rowdiness was never a problem.

But a growing feud between Short and former city marshal Jim Courtright changed that. A heated exchange of words between the two men ended with a gunfight on the boardwalk outside the saloon. When it was over, Courtright lay dead in the doorway of a shooting gallery. An inquest the next day declared the shooting a case of self-defense, and Short was exonerated. (Right, courtesy of Phil Gessert; below, courtesy of Jon Holiday, Lagniappe Productions.)

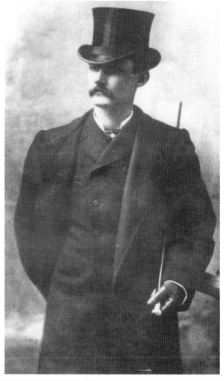

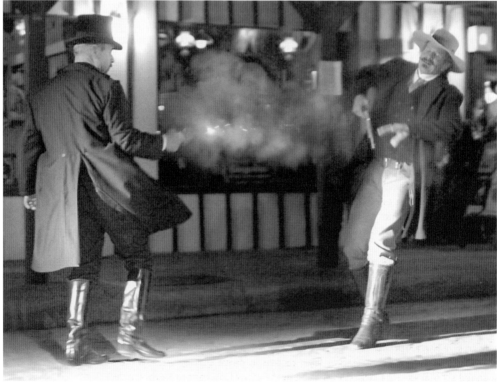

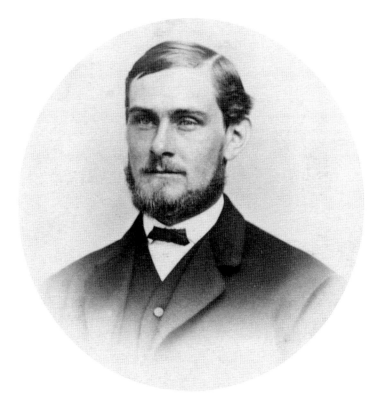

**Timothy Isaiah "Longhair Jim" Courtright**
Jim Courtright was probably the best marksman of his day. It was also his undoing.

People who knew him in the late 1800s said he was such a crack shot, he would follow the volunteer fire corps out to a blaze and shoot down fence wires with his pistol. Some said he was faster on the draw than Wild Bill Hickok, Wyatt Earp, and Bat Masterson.

A Civil War veteran, who was later elected Fort Worth marshal three times, Courtright was arrested for allegedly murdering 14 trespassers while working as a guard for the American Mining Company in Silver City, New Mexico. US deputies were trying to extradite him back to New Mexico from Fort Worth when friends arranged his escape by providing him with guns and a getaway horse. He was later acquitted of the charges due to insufficient evidence.

Fate finally caught up with him one evening at the White Elephant Saloon. Accounts differ about what happened between Courtright and Luke Short, a renowned gambler and part owner of the saloon. Some say that the former marshal was hired by a rival gambler to kill Short. Others say that Courtright was operating a detective bureau and was "shaking down" the saloon's gambling operation for protection money, and Short did not like it. Whatever the circumstances, between 8:00 and 9:00 p.m. on February 8, 1887, one of the most famous gunfights in Western history took place in Fort Worth, and one man ended up dead.

Vic Jossenberger, who was 16 at the time, witnessed the incident and recounted it 60 years later. "Jim had sent someone home for his guns, and his wife had sent him a single action. He had to fan it, and while he was fanning, Luke got him," Jossenberger remembered.

Courtright was shot twice and, as he lay dying near the doorway of the White Elephant, Short shot him again between the eyes, according to Jossenberger.

"It's too bad Jim's wife sent him the wrong gun. If he had the double action, Luke wouldn't have been able to give him a haircut."

Courtright's friends remained as loyal to him in death as they were in life. His funeral procession spanned six blocks—the largest ever seen in the city. (Courtesy of Kevin Foster.)

## J. Frank Norris

J. Frank Norris, one of the 20th century's notable leaders of Bible fundamentalism, tried to douse the immoral fires of Hell's Half Acre in Fort Worth. This seedy part of the city was home to brothels and bars. Norris preached against the vices from the pulpit of the First Baptist Church for 44 years. His crusade against corruption, gambling, liquor, and horse racing earned him a collection of enemies—especially when he began revealing the names of gamblers and drinkers in his sermons.

Norris's church burned down twice, but he always rebuilt. Progress—not preaching—finally cooled Hell's Half Acre. Government plans for a nearby military camp forced Fort Worth police to crack down on the city's criminal activity with raids and hefty fines. (Courtesy of First Baptist Church of Fort Worth.)

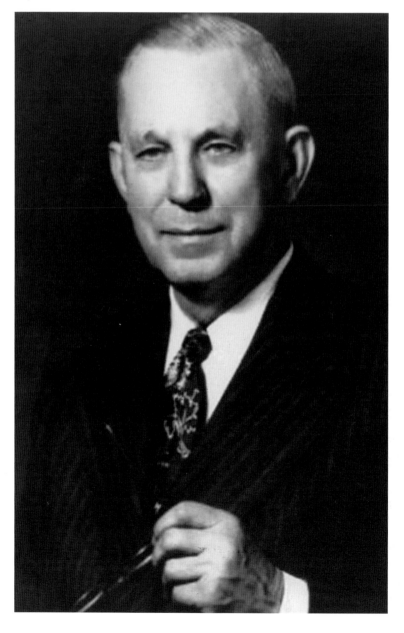

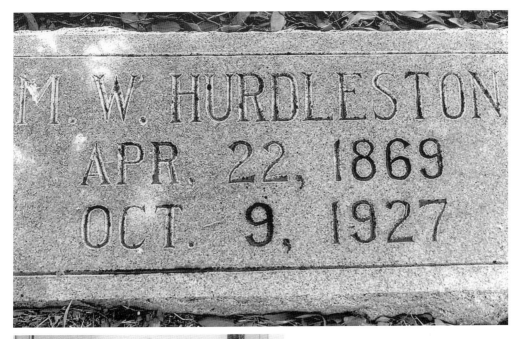

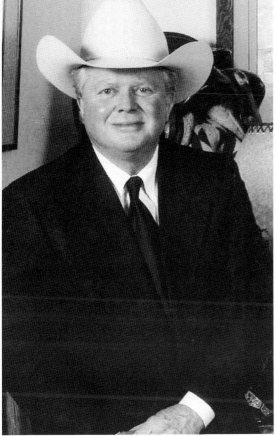

### Mordecai W. Hurdleston

During his brief, two-year term as police commissioner, Mordecai Hurdleston reformed the Fort Worth Police Department. He hired the first college-educated police chief, stopped the practice of giving officers reward money, and ordered patrolling cops not to hang out in saloons. At the same time, the commissioner instituted the eight-hour work shift, honored retiring officers, and supported the Police Benevolent Association. Hurdleston advanced the image of officers as public servants. (Courtesy of Kevin Foster.)

### Jim Lane

Jim Lane is all Fort Worth. The six-time former city councilman is proud of his upbringing on the city's Northside where he practices law and serves on the Fort Worth Stockyards Improvement Authority, Inc., and Tarrant County Regional Water District Board. An advocate of keeping the history and culture of Native Americans and the Old West alive, he supported the idea of a daily cattle drive in the stockyards. (Courtesy of Jim Lane Law Office.)

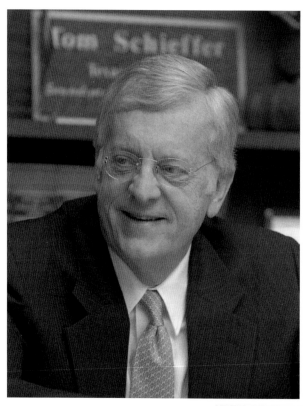

**Tom Schieffer**

Tom Schieffer gained election to the Texas legislature early in his career. He served on many civic boards and committees and supported numerous charities in Tarrant County. Schieffer also worked for the Texas Rangers and LA Dodgers. His national influence increased in 2001 when he became the US ambassador to Australia and then the ambassador to Japan in 2005, a post he manned until 2009. (Courtesy of Ambassador Tom Schieffer.)

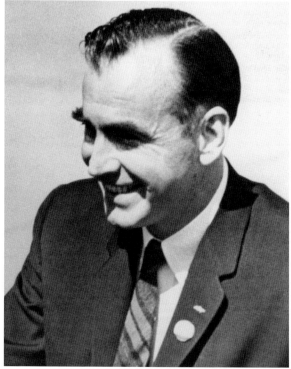

**James Wright**

From 1946 to 1989, James Wright served as mayor, state representative, US House Majority Leader, and US Speaker of the House—all after his World War II service in the Pacific. Yet, a scandal surrounding his aide and an ethics inquiry cast a shadow over his time in Washington. Wright is most known in the Dallas/Fort Worth (DFW) area for the Wright Amendment, a law limiting air traffic from Love Field. (Courtesy of Special Collections, Texas Christian University.)

**Kay Granger**
For five generations, Kay Granger's family has called Fort Worth home. She was first a teacher and then a business owner for 23 years before becoming the first female mayor of Fort Worth. In 1997, Granger won the congressional spot for the 12th District of Texas, making her the first woman elected from that district and the first and only female to serve as a Republican member of Congress from Texas. (Courtesy of the Office of Kay Granger.)

**Hon. Debra H. Lehrmann**
Justice Debra H. Lehrmann received appointment to the Supreme Court of Texas in 2010 after serving as a district judge in Fort Worth's 360th District. Prior to her career on the bench, Justice Lehrmann worked as an attorney with Law, Snakard & Gambill. She regularly writes and lectures about children's rights in the legal system, even implementing the "access facilitator" process in Tarrant County courts. (Courtesy of Justice Debra H. Lehrmann.)

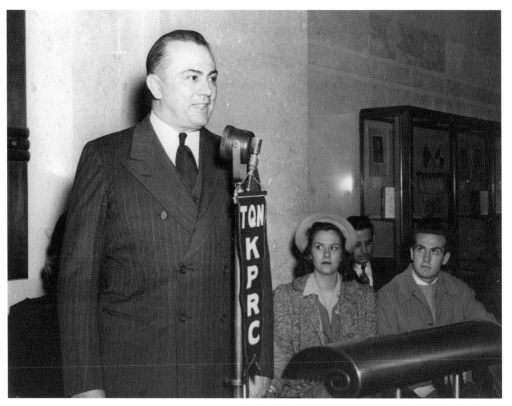

### Wilbert "Pappy" O'Daniel

Although "Pappy" O'Daniel served as Texas governor and US senator, he is best known for his contributions to music and radio. He often used his radio show and penchant for forming bands—most notably the Hillbilly Boys and the Light Crust Doughboys—to propagate his political and religious ideology. (Courtesy of Texas State Library & Archives Commission.)

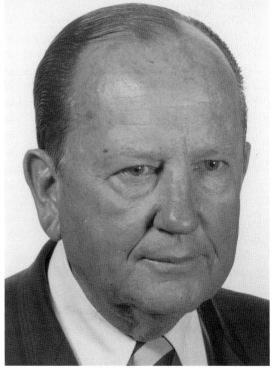

### Doyle Willis Sr.

Always a champion for the underdog, Doyle Willis Sr. served Fort Worth by spending 42 years in the Texas House and Senate (during four separate stints). As a World War II veteran and Bronze Star recipient, Willis supported military families any way he could. He also labored to improve work conditions and benefits for law enforcement and firefighters. (Courtesy of the Willis family.)

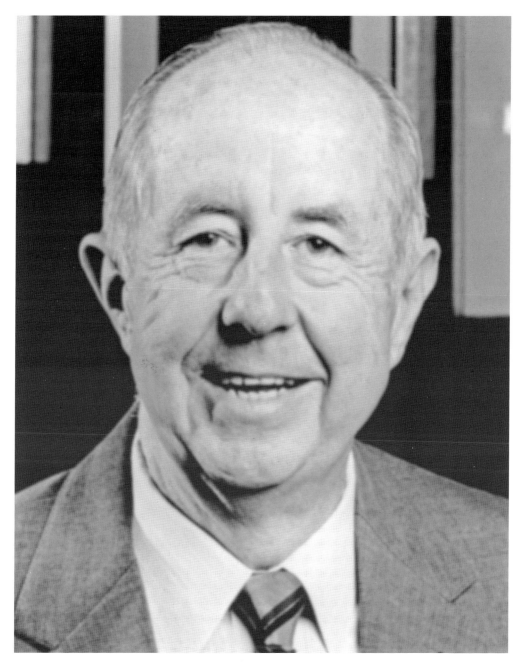

Robert "Bob" Bolen

Bob Bolen served as mayor of Fort Worth from 1982 to 1991, and his accomplishments in office are still felt today. He helped establish the first Public Improvement District (PID) downtown, attracted the US Treasury's Bureau of Engraving and Printing to the area, and championed the public-private partnership known as the AllianceTexas. The development project's economic impact on Fort Worth is more than $43 billion. Bolen also founded and served as chief executive officer of Bolen Enterprises. Bolen, a Texas A&M graduate, was a visiting lecturer and senior advisor to the dean of the M.J. Neeley School of Business at Texas Christian University at the time of his death in 2014. (Courtesy of Bob Bolen.)

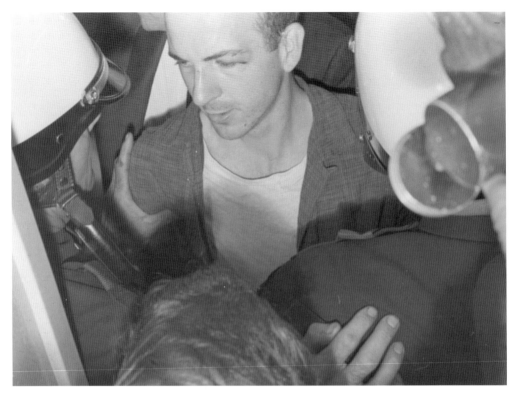

### Lee Harvey Oswald

Born in 1939 to Robert Edward Lee Oswald Sr. and Marguerite Claverie, Lee Harvey Oswald is perhaps Fort Worth's most notorious individual. Although he and his family lived in numerous states and cities, Oswald spent many years in Texas. The Warren Commission declared him to be the sniper who assassinated Pres. John F. Kennedy.

Oswald joined the Marines in 1956 but defected to the Soviet Union in 1959—only to return to the DFW area in 1962 with a new wife and daughter.

His biography portrays a boy who struggled with emotional distress and a man conflicted about his beliefs and prone to awkward political activism.

On November 22, 1963, at 12:30 p.m., government officials believe Oswald shot President Kennedy from the sixth floor of the Texas School Book Depository as the president and his motorcade traveled through Dealey Plaza in Dallas. President Kennedy was pronounced dead at 1:00 p.m. Sometime around 1:15 that afternoon, Oswald also shot and killed J.D. Tippit, a Dallas police officer, when he approached Oswald to question him. Around 2:00 p.m. Oswald was taken into custody and ushered to the police department building.

After hours of interrogation, on November 24, police attempted to move Oswald from police headquarters to a county jail, but he never made it. Dallas nightclub owner Jack Ruby shot Oswald in the abdomen. He died at 1:07 p.m. that day.

With only a handful of family and several reporters, Oswald was buried in the Rose Hill Memorial Burial Park in Fort Worth.

Since Kennedy's death, numerous theories and investigations have purported that Oswald was not the shooter. His widow, Marina Oswald Porter, claimed the CIA and mafia set up her husband—a belief she continues to hold. (Courtesy of *Fort Worth Star-Telegram* Collection, Special Collections, University of Texas at Arlington Library, Arlington, Texas.).

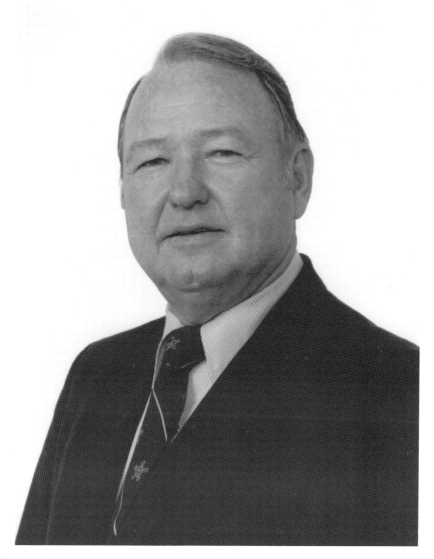

**Mike Howard**

Mike Howard was an eyewitness to one of the most pivotal events in modern US history. A Secret Service agent from 1960 to 1974, he accompanied Pres. John Kennedy and his wife, Jacqueline, to Texas in November 1963 and was part of the investigation following the assassination in Dallas. Howard, who served as police chief in nearby Saginaw from 1957 to 1961, was the only member of President Kennedy's security detail from Tarrant County.

Familiar with the area, he was part of the advance team that secured President Kennedy's room at the Texas Hotel and questioned several local residents considered a threat by the Secret Service. After the assassination, Pres. Lyndon Johnson tasked Howard with protecting Lee Harvey Oswald's family from vigilante violence.

He joined President Johnson's security detail and moved with him to the LBJ Ranch after the president left office. (Courtesy of Mike Howard.)

## Cullen and Priscilla Davis

Thomas Cullen Davis was one of the richest men in America tried for murder. He won the legal battle but lost his fortune.

At one time, the privately held oilfield supply and production company he and his older brother Ken Jr. inherited from their father was worth an estimated $400 million. But what made T. Cullen Davis a household name was not wealth, but his arrest for the August 2, 1976, nighttime shooting spree that killed two people inside his 20-room Fort Worth mansion.

His estranged wife, Priscilla, said Davis—dressed in black and wearing a woman's wig—was the person who confronted her inside the $6-million hilltop mansion with a gun hours after a contentious ruling in their divorce case. The mysterious man shot the socialite and killed her boyfriend, Stan Farr, and her 12-year-old daughter, Andrea Wilborn. Another friend, Gus Gavrel, who was visiting the home, was wounded in the attack.

The oil baron was acquitted in the death of Wilborn after one of the most expensive trials in Texas history. Later, a civil jury in Tarrant County determined he was not liable for the 1976 slayings.

The billionaire's legal woes continued in 1978 when Davis was prosecuted for allegedly hiring a hit man to murder the judge in his divorce case. He was again acquitted of the charge. The trial, *Texas v. Davis*, is cited as one of the first uses of forensic analysis of tape-recorded evidence in a legal setting.

Davis lost his fortune during the early-1980s recession. Bad real estate investments were partly to blame. In 1986, he filed for personal bankruptcy listing assets of $600,000 and debts of more than $230 million.

In 1980, Cullen Davis publicly professed a conversion to the Christian faith.

Priscilla Davis, known for her flashy style of dress in the 1970s, died of breast cancer in 2001. She never wavered in claiming ex-husband Davis was the man behind the 1976 murders. Her lasting regret was that justice was not served.

Captivating Texans and the rest of the country, the high-profile murder mystery was the subject of numerous books and a television miniseries. Hollywood insiders say the dastardly J.R. Ewing character on the hit television series *Dallas* was based on Cullen Davis. (Courtesy of *Fort Worth Star-Telegram* Collection, Special Collections, University of Texas at Arlington Library, Arlington, Texas.)

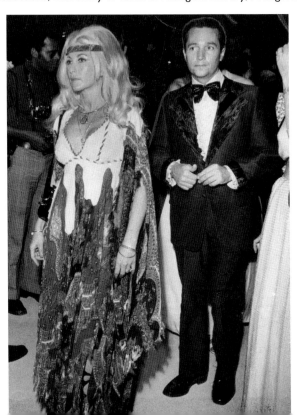

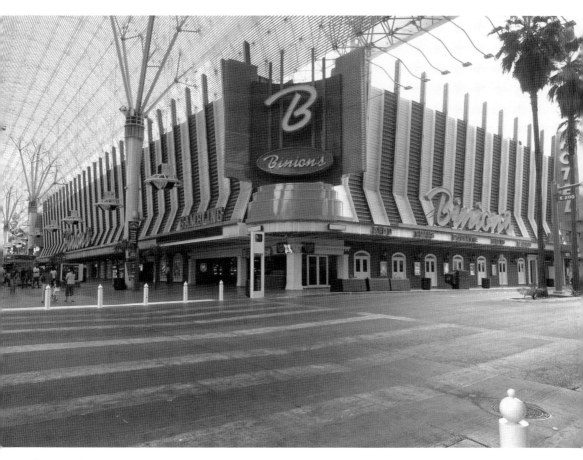

**Benny Binion**
Benny Binion is perhaps the most colorful character to pass through Fort Worth. With a reported FBI file containing accounts of theft, gun possession, moonshine peddling, gambling, murder, and even mob connections, Binion's years in Texas were interesting to say the least. In the 1950s, Binion opened the Horseshoe Casino in Las Vegas, establishing a new type of gambling experience in Glitter Gulch. The success of the gambling hall grew exponentially; in 1970, Binion created the World Series of Poker, played, of course, at Horseshoe Casino. Binion died in 1989, but his children carried on his gambling legacy amidst legal battles and debt issues. The casino sold in 2004 and now operates as Binion's Gambling Hall and Hotel. (Courtesy of Binion's Gambling Hall.)

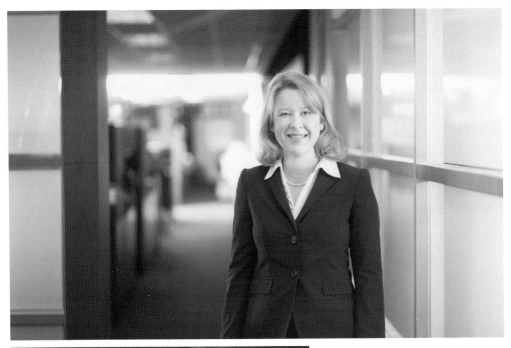

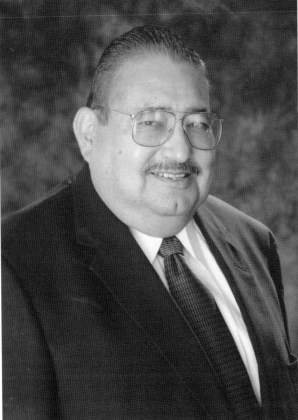

**Natalie S. Brackett**

Natalie S. Brackett practices law at Shannon, Gracey, Ratliff & Miller, LLP, focusing on probate and trust matters. She is a modern-day force, who strives for balance in work and home life. As an active volunteer, Brackett believes integrity and ethics impact every aspect—from litigation to community service. She is known as a problem solver, not a problem creator. (Courtesy of Shannon, Gracey, Ratliff & Miller, LLP.)

**Louis Zapata**

Louis Zapata grew up in the shadows of the Tarrant County Courthouse. In 1977, he became the first Hispanic elected to the Fort Worth City Council after single-member districts were formed. Zapata was an effective councilman and won six more terms to the council. His resume includes time as the chairman of the board of directors for the Dallas/Fort Worth International Airport. (Courtesy of Louis Zapata.)

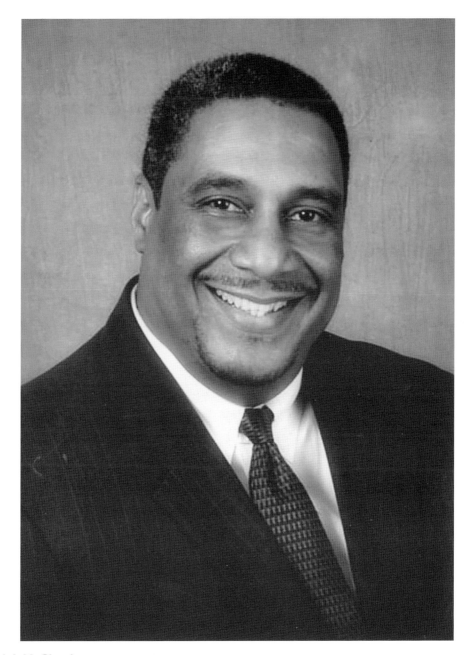

**Ralph McCloud**

Ralph McCloud is a dedicated advocate of social justice causes. Elected a Fort Worth city councilman from 1997 to 2005, he chaired the mayor's commission on homelessness. The former mayor pro-tem was president of the Fort Worth Local Housing Development Council and served four terms on the National League of Cities' Human Development Steering Committee.

Outside political office, he coordinated Peace and Justice Ministries for the Diocese of Fort Worth and founded the African American Summit for Peace, Justice, and Equality. In November 2007, he was named director of the US Conference of Catholic Bishops' Catholic Campaign for Human Development. (Courtesy of Ralph McCloud.)

**Amanda Bush**

Amanda L. Bush, partner at the Fort Worth offices of Jackson Walker, LLP, practices in complex commercial litigation, intellectual property litigation, and media and First Amendment litigation. Bush—who married George P. Bush, the grandson of Pres. H.W. Bush—thrives in her career, earning numerous accolades for her successes in the courtroom. In 2012, she received recognition as one of the "40 Under 40" by *Fort Worth Business Press*; Bush also garnered "Rising Star" status by Thomas Reuters (2007–2012) and "Top Attorney" honors by *Fort Worth, Texas* magazine.

Bush served on the board of directors of the Van Cliburn Foundation and on the executive committee and board of directors of the Fort Worth Symphony Orchestra. She chaired the annual Barbara Bush Foundation for Family Literacy's Dallas/Fort Worth Celebration of Reading. (Courtesy of Jackson Walker, LLP.)

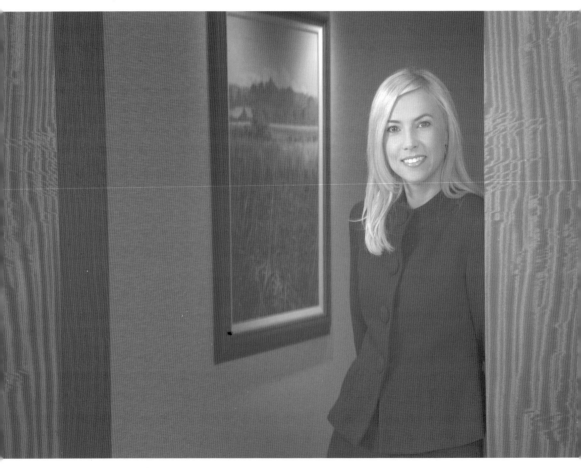

# CHAPTER THREE

# Hometown Heroes

Heroes come in all shapes and sizes and tackle a myriad of problems. From the battlefield to education to benevolence, Fort Worth's hometown heroes reveal this community's commitment to making a difference. Known as a city of volunteerism, this chapter highlights only a sampling of the individuals who chose to step out of their comfort zones and act for the benefit of others.

During an era when orphans were often institutionalized, discarded, and faced bleak futures, Edna Gladney worked tirelessly to create reforms to recognize the value of adopted children and to pass legislations in support of adoption.

Stephen Seleny believed a strong education included exposure to and experience with the arts. His passion for this philosophy prompted him, along with George Bragg, to establish Trinity Valley School, which is now one of the premiere private schools in Fort Worth.

Sometimes it is the simple acts of compassion and courage that make a difference in people's lives. Rosemary Hayes rolled up her sleeves and salvaged tons of useable produce when a delivery truck overturned in Fort Worth. The still edible heads of lettuce and kale fed hundreds of homeless, hungry people at soup kitchens and shelters later that day.

Comforting children is the life mission of Peggy Bohme and Connie Koehler. After Bohme's 14-year-old son died from bone cancer in 1984, the grieving mother channeled her loss into a foundation that continues to help hundreds of children cope with the death of a loved one. The WARM Place provides grief support services to children ages 3–18 and their families free of charge.

Retired pediatric nurse Connie Koehler is raising money for the first freestanding pediatric hospice and respite care facility for medically fragile children in the Texas. Angel Unaware will support the complex needs involved in end-of-life care.

To be extraordinary or to be heroic does not require an impressive pedigree, transcript, or resume. The heroes found on the following pages are regular, everyday people who decided to fix the problems they encountered, to stand up for the bullied and abandoned, and to champion a cause for change.

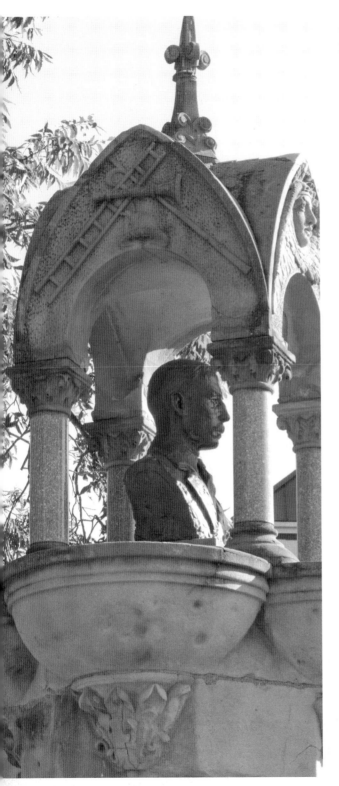

### Al Hayne

Alfred S. "Al" Hayne is considered Fort Worth's first true hero. On the night of May 30, 1890, the 39-year-old British civil engineer lost his life but saved others when a fire engulfed a newly built exhibition hall.

A workhorse, Hayne rarely took advantage of Fort Worth's nightlife, but on this spring evening, he decided to attend a fancy dance ball at the Texas Spring Palace. Opened a year earlier, the structurally impressive venue was designed to attract settlers and investors by showcasing the state's cereal, grasses, and farm products. A cotton display filled the exhibit hall the evening Hayne visited.

One newspaper account said a spark caught a bundle of pampa grass on fire, and the blaze quickly spread up the staircases. Fire chief Don B. Adams was in the building when the fire erupted. He sounded alarm box No. 222 and opened the valves of standpipes installed in the hall, but the hall "burned like a pine box."

An estimated 7,000 people were inside the building and some became trapped by the flames. Eyewitnesses to the tragedy watched as Hayne lowered women and children by rope out of windows and led others blinded by smoke to safety. His last act of heroism was to hurl an unconscious woman out a window to the arms of bystanders before jumping out himself.

But, there was no one to catch the good Samaritan. He fell to the ground with enough force to break a leg and injure his spine. Hayne also suffered burns to most of his body and died a few hours later. He was the only Texas Spring Palace fire fatality.

A standing-room-only crowd turned out for his funeral on June 5, 1890. The graduate of England's elite Eton Prep School, who went on to earn a university degree, was interred in Fort Worth's historic Oakwood Cemetery. When his family arrived from England after the burial, his body was exhumed for a final viewing. The Al Hayne Memorial Park at 225 West Lancaster Street is named for him. (Courtesy of René and Peter van der Krogt.)

**Maj. Horace Seaver "Stump" Carswell Jr.**

From 1942 until it officially closed in 1993, Carswell Air Force Base trained airmen and maintained military equipment used during World War II, Vietnam, and the Persian Gulf War. But few people know the facility was named for Medal of Honor recipient Horace Seaver "Stump" Carswell Jr. The Fort Worth native died in 1944 after his B-24 was crippled during a bombing run against a Japanese convoy in the South China Sea.

While maintaining control of the failing aircraft, Major Carswell ordered his crew to bail out. When one crewmember reported his parachute was ripped and unusable, the pilot refused to save himself but stayed with his comrade and attempted a crash landing. Both died when the airplane struck a mountainside and burned.

The TCU graduate was posthumously awarded the Distinguished Flying Cross and Purple Heart and later received the Medal of Honor for "consummate gallantry and intrepidity" shown in trying to save all members of his crew. He is buried in China. (Courtesy of the Congressional Medal of Honor Society.)

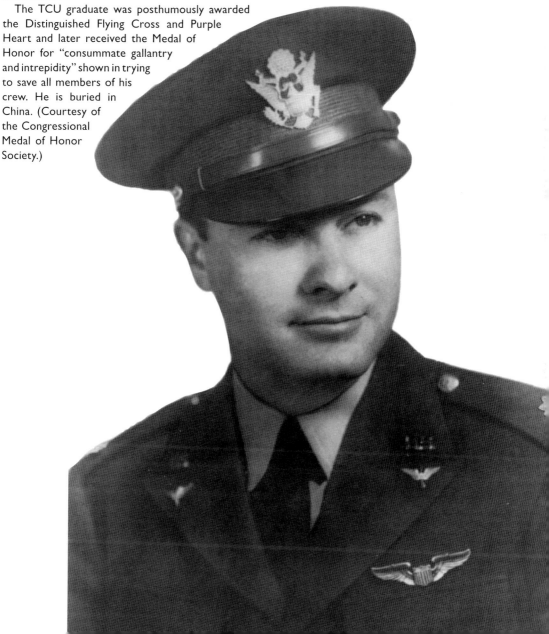

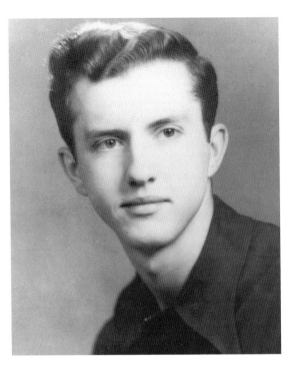

**Charles F. Pendleton**
Charles Pendleton left Paschal High School before graduation to join the Army. The 21-year-old soldier was killed by enemy mortar fire on July 17, 1953, and posthumously awarded the Purple Heart and Medal of Honor for a "courageous defense of his position and fellow soldiers" during the Korean War. His widow donated the Medal of Honor to Paschal—one of the few high schools in the United States so honored. (Courtesy of the Congressional Medal of Honor Society.)

**Daniel Walker**
When protestors burned an American flag outside the 1984 Republican National Convention in Dallas, Daniel Walker retrieved the charred remains for burial as television cameras watched. For his patriotism, the West Point graduate received the Army's highest civilian award and received a letter of commendation from Pres. Ronald Reagan. The 1984 incident led to the 1989 *Texas v. Johnson* US Supreme Court decision upholding flag burning as a form of political expression. (Courtesy of Dana Purczinsky.)

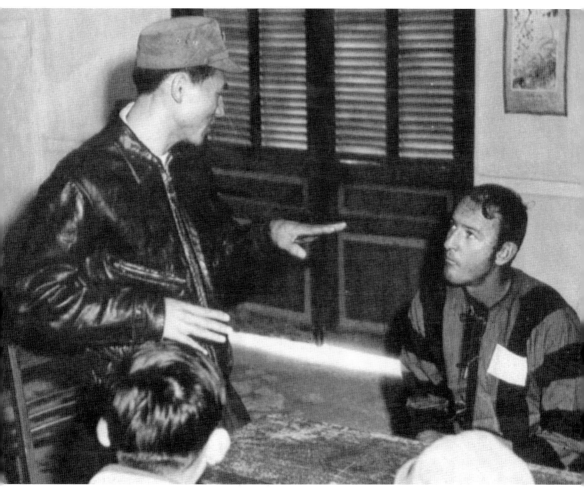

**Lt. Col. John H. Yuill**

When the Viet Cong captured Lt. Col. John H. Yuill (seated) after his B-52 was shot down over Hanoi on December 22, 1972, the pilot remembers doing two things.

"I thanked God for my life," he continued. "Then I asked Him to let me return home so I could spend more time with my wife, Rose, and children."

The father of seven was on his second tour of duty during the Vietnam War when he became part of the "Linebacker II" bombing raids. Frustrated by protracted peace negotiations and public pressure to end the conflict, Pres. Richard Nixon ordered the concentrated air offensive to destroy enemy targets between Hanoi and Haiphong. Yuill's crew was on its third bombing run in four days when missile fire hit the B-52. It was the only crew from Fort Worth's Carswell Air Force Base shot down during Linebacker II, and it was the only crew to survive intact with no casualties.

After capture, Yuill faced heavy interrogations and was threatened repeatedly that his crew would be tried as war criminals.

Lieutenant Colonel Yuill remained imprisoned in a POW camp for three months until a peace treaty forced his release in March 1973. He never compared himself to other POWs from the Vietnam War who were tortured and spent years in confinement.

"I am honored to be associated with these men," said the Fort Worth resident who retired from the Air Force in 1979. "I cannot say enough about their courage, faith, and leadership. I will say that my short stay in Hanoi reaffirmed my faith in God, friends, and country." (Courtesy of Katheryn Shaw.)

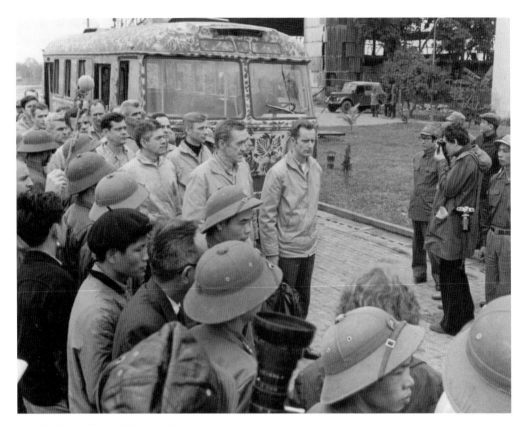

## Col. Robert "Percy" Purcell

Col. Robert "Percy" Purcell (third in the line of prisoners) spent 2,758 days as a POW in Vietnam, but that is not what made him a hero. His perseverance, courage, and willingness to help fellow POWs during their mutual captivity made him a legend among his peers.

Purcell was flying his 25th combat mission in the F-105 Thunderchief when he was shot down over North Vietnam in July 1965. After capture, the fighter pilot was tortured, beaten, and starved but never defeated.

By tapping on prison walls, Purcell offered encouragement to other POWs. When guards withheld food from Jon Reynolds because he refused to write an antiwar letter, Purcell devised a way to sneak pieces of bread to him through a light socket in the ceiling. The courageous gesture gave the starving prisoner "a massive rise in morale," Reynolds remembers. Risking a severe beating and confinement in "the tank," which was a small, unlit cell, Purcell repeated what became known as the "cookie caper" to help two other POWs.

After returning home in 1973, Purcell continued his military career until he retired in 1980 from Carswell Air Force Base. He is the recipient of the Silver Star, two Bronze Stars for valor, two Purple Hearts, two Legions of Merit, and a Distinguished Flying Cross.

The Fort Worth resident died in 2009 at the age of 78, but his valor and service is remembered at Percy's House. Donated by a local builder to honor the war hero, the appropriate memorial serves as a resettlement home for children from war-torn countries that no longer have a parent or guardian. (Courtesy of Suzanne Purcell.)

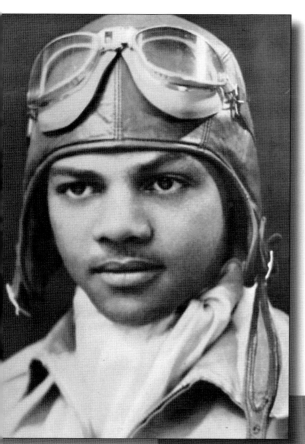

### Capt. Claude R. Platte

When Claude R. Platte was seven, he watched an airplane fly over his South Fort Worth home and told his dad he wanted to become a pilot.

A dozen years later, Platte fulfilled that dream. The Tuskegee Institute graduate became one of the first African American aviators in the US Armed Forces. His group of African American World War II fighter pilots was known as the Tuskegee Airmen. Their story was told in the 2012 movie *Red Tails*.

The first black officer, trained and commissioned in the US Air Force Pilot Training Program at Randolph Air Force Base, Platte advanced to the rank of captain and served in the Air Force 18 years. A flight instructor, he trained more than 400 black cadets. Platte received numerous awards, but his greatest honor came in 2007 when the "unique military record" of the Tuskegee Airmen was recognized with the Congressional Gold Medal. (Left courtesy of Erma Platte; below, courtesy of Jerry Circelli.)

### Dr. W.S. Lorimer Jr.

A R.L. Paschal High School graduate, Dr. W.S. "Bill" Lorimer Jr. is one of the most influential surgeons in Fort Worth's history. He, along with his father, Dr. Lorimer Sr., a local family practice physician, started the Lorimer Clinic in the 1950s. By 1960, Dr. Lorimer Jr. accepted an additional position as the director of medical education at St. Joseph's Hospital, the first role of its type in Texas. He recruited top students to the struggling intern program, impacting the quality and organization of the training. At the same time, Dr. Lorimer Jr. was the chief of surgery at John Peter Smith Hospital. According to Dr. Lorimer Jr., his greatest medical achievement was the removal of a "parasitic twin" from a young girl. Performing a series of surgeries, he used skin from the undeveloped Siamese twin to cover the girl's exposed abdomen. When the child was 18 months, Dr. Lorimer Jr. completed the final surgery to remove the remaining attachments. (Courtesy of Dr. W.S. Lorimer Jr.)

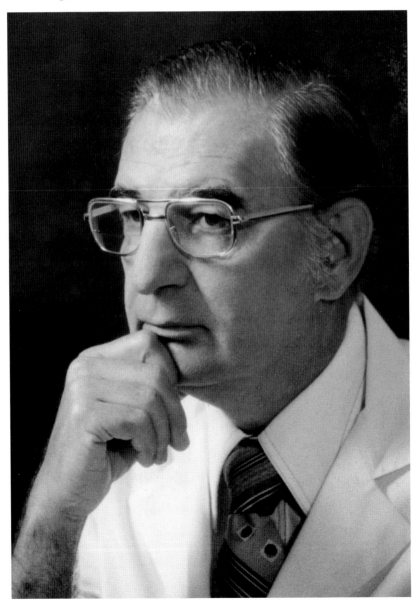

**Dr. Lorimer and Sons**
Born to a physician father, Dr. Lorimer Jr. carried on the family tradition of raising future doctors. Two of his children became area practitioners. During his 42-year career, Dr. Lorimer Jr. also won several accolades, served on various boards, and joined many prestigious organizations. He even petitioned the Fort Worth Independent District (FWISD) to include swimming in its physical education curriculum; his recommendation was instituted the following school year. (Courtesy of Dr. W.S. Lorimer Jr.)

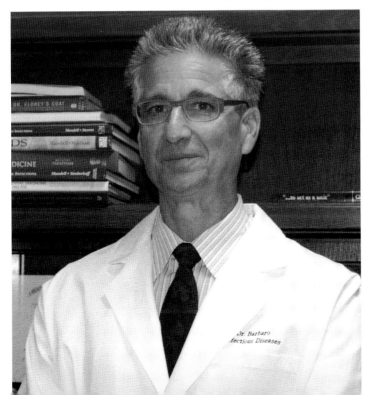

Dr. Barbaro
fectious Diseases

**Dr. Daniel Barbaro**
Dr. Daniel Barbaro entered the field of infectious disease before the HIV/AIDS epidemic erupted in the 1980s. In a lawsuit filed against a Dallas hospital and training institution, Dr. Barbaro testified about the lack of care HIV patients received. In his own Fort Worth clinic, started in 1992, he dedicated his practice to raising the standard for patient treatment and to participating in investigative studies. (Courtesy of Emily White Youree.)

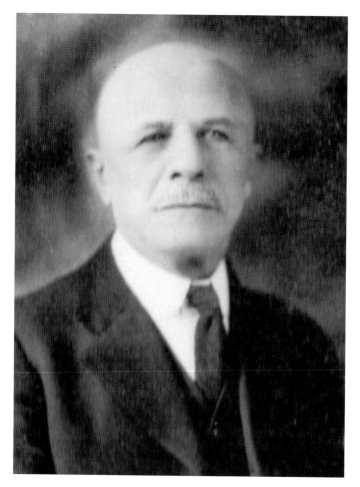

### John B. Laneri

John B. Laneri was an Italian immigrant who came to Fort Worth in 1883 and became a successful businessman by opening the Fort Worth Macaroni Co. It was renamed (Our Best) O.B. Macaroni in 1959 and still provides pasta to food-service, industrial, and retail customers throughout the United States. Laneri also established the first Catholic high school in the city.

Born in Genoa, Italy, in 1858, Laneri was 15 years old when he arrived in the United States. His first job was sweeping floors and delivering packages at a confectionery shop. A quick learner who adapted to the customs of his new country, he was soon promoted to sales clerk. After living in Galveston and Marshall, Texas, he moved to Fort Worth in 1882 and prospered in the food and liquor business as well as real estate. In 1899, he provided the financial backing to establish the Fort Worth Macaroni Company and was named president. The company moved to a converted carriage house in 1905 and shipped pasta products all over the greater Southwest from its railroad siding. After Laneri's death in 1935, family members continued to operate the business for more than 100 years. O.B. Macaroni was sold to JGR Enterprises, a US-based company, in 2009.

Laneri was an early member of the board of trade and director of the Fort Worth National Bank.

A philanthropist, Laneri funded construction of an all-boys' Catholic school on Hemphill Street in memory of his wife, Nannie. Laneri College, later renamed Laneri High School for Boys, was dedicated on October 30, 1921, and provided classroom instruction for boys in fifth grade through twelfth grade. It closed in 1962, and students were transferred to the newly opened coeducational Nolan Catholic High School. Today, the building houses Cassata High School. (Courtesy of Fr. David Bristow.)

**Sr. Mary Bonaventure Magnum, SHSp**
She was a legendary educator with a passion for inclusiveness. St. Mary Bonaventure cofounded the Cassata Learning Center in 1975 with Sr. Mary Fulbright, SSMN, for students who dropped out or could not succeed in a traditional classroom. Cassata was one of Fort Worth's first alternative secondary schools. Sister Bonaventure died in 2007 at age 93, but the diocesan school she started continues to transform struggling youth into high school graduates. (Courtesy of Cassata High School.)

**Paul W. Greenwell**
Paul Greenwell's biggest investments are in people. The vice president of Luther King Capital Management Corporation is the founder of the STAR (Success Through Academic Readiness) Sponsorship Program in Fort Worth. Started in 1993, the program provides low-income families the opportunity to give their children a private school education. Many STAR recipients succeed in high school and go on to earn college scholarships. (Courtesy of STAR, Children's Scholarship Fund, Fort Worth.)

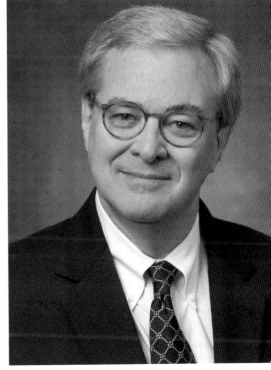

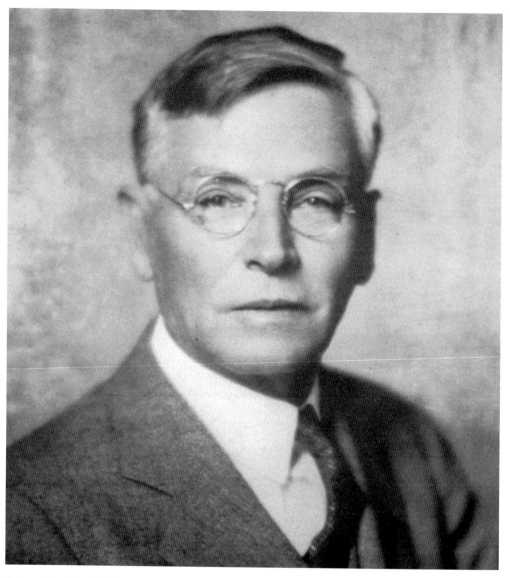

**Robert Lee Paschal**

After trying to exit the teaching field, Robert Lee Paschal traveled to Fort Worth to study law, but that was not to be his fate. In 1894, Paschal accepted the principal's position at the Missouri Avenue School, which was the beginning of an education career in Fort Worth that lasted 45 years.

He took on the principal's role at Fort Worth High School (later Central High School) in 1906 where he worked until he retired. During his tenure, Paschal signed more than 8,000 diplomas. After his exit, the school was named R.L. Paschal High School.

Not only did Paschal contribute greatly to the day-to-day management of local schools, but he also served as president of the Texas State Teachers Association and the West Texas Teachers Association. (Courtesy of Billy W. Sills Center for Archives, FWISD.)

**Alice Contreras**
Committed to the schooling of immigrant children, Alice Contreras parlayed her teaching career into the directorship of the bilingual education department. Lubbock Avenue Elementary was renamed Alice D. Contreras Elementary shortly after its opening in 2000. This school encapsulates Contreras's philosophy by offering traditional and dual-language programs as well as curriculum for special needs students. (Courtesy of Billy W. Sills Center for Archives, FWISD.)

**Christene Moss**
Christene Moss, who grew up in the Como neighborhood, has served the Fort Worth Independent School District since 1990; in 2013, she became president of the board. She is a champion for literacy and equal education opportunities for minority children. The elementary school on Eastland Street is named in her honor. (Courtesy of FWISD.)

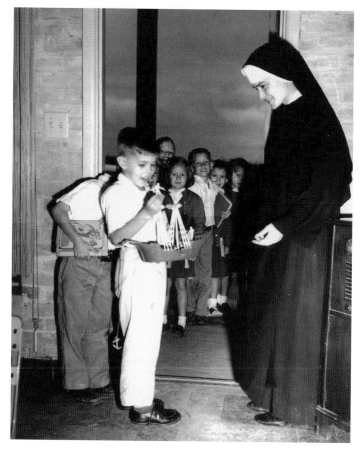

## Sisters of St. Mary of Namur

They were a small group of Belgian and American sisters who came to Fort Worth in 1885 with a purpose—to educate children, especially the poor. Their mission started with a small boarding school, St. Ignatius Academy, located adjacent to St. Patrick Cathedral in downtown Fort Worth.

When student enrollment outgrew that location, they opened Our Lady of Victory (OLV) Academy and College for young women. Housed in a five-story redbrick building, the impressive structure loomed large against the backdrop of Fort Worth's south side prairie. The school accepted day and boarding students from kindergarten through junior college and attracted pupils from as far away as West Texas. Ranchers and rural families sent their daughters to the sisters for scholastic, artistic, religious, and cultural training. The sisters are credited with offering the first desegregated school in Fort Worth. Sister Francesca (pictured) welcomes students as they arrive at Holy Name School in 1958.

When families from Mexico and Central America began settling in north Fort Worth, the religious order opened San Jose School inside a three-room frame structure. Dedicated in 1926, the building housed two grades in each classroom. The school later merged with All Saints School.

In 1961, OLV Academy closed and students were sent to the newly opened coeducational Nolan Catholic High School. College classes moved to the University of Dallas with the Sisters of St. Mary partially staffing both institutions.

At one time, the order operated nine boarding schools, numerous parochial schools in Texas, and three missionary schools for Mexican immigrants in Texas. OLV Elementary School in Fort Worth is still owned and operated by the Sisters of St. Mary of Namur.

The religious order celebrated 150 years of ministry in the United States in 2013. (Courtesy of Sisters of St. Mary of Namur Archives.)

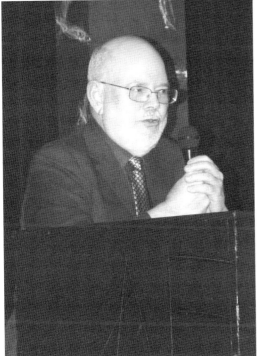

### Lily B. Clayton

Lily B. Clayton (left table, second from the front) traveled with her mother to Fort Worth in 1884, hoping to secure a teaching job. Four months later, she joined the two-year-old school district as a teacher, eventually teaching Latin and math at the Fort Worth High School. When she retired in 1935, after 50 years of service, the elementary school on Park Place was named in her honor. (Courtesy of Billy W. Sills Center for Archives, FWISD.)

### John Hamilton

John Hamilton, a longtime educator at R.L. Paschal High School, is responsible for the Advance Placement (AP) program. From 1977 to 1993, he served as the mathematics department chair. During his tenure, he taught students the fundamentals of math in basic algebra classes and challenged students' minds in AP calculus. In 1984, he developed the academic coordinator position for the FWISD. (Courtesy of Crissa Sigl, Paschal High School.)

**Manuel Jara**

As a young child, Manuel Jara lived a migrant lifestyle. His parents fled the horror of the Mexican Revolution to travel by boxcar from one Texas railroad town to another looking for work. They finally settled in Fort Worth where Manuel began his formal education in a public school. He earned a high school diploma, served in World War II, and eventually became the owner of the Jara Printing Company.

But he never forgot the poverty and disadvantage of his early years. As a successful businessman, Jara encouraged respect and goodwill between different ethnic groups in the community. In 1973, he received the Brotherhood Citation of the National Conference of Christians and Jews—the first Mexican-American to receive the award. During his life, the active civic leader was a member of 17 different boards, including the United Way, Salvation Army, and North Texas Commission. At the time of his death, he was spearheading a relief effort to aid victims of the devastating 1985 earthquake in Mexico City.

Jara received a Distinguished Alumnus Award from the FWISD, and in 1988, the district renamed Circle Park Elementary the Manuel Jara Elementary School to honor the man known for always saying, "kindness is spoken here." (Courtesy of JoLinda Martinez.)

### Clem Constantine

Clem Constantine, the former executive of Catholic Charities Fort Worth, was a champion of refugee resettlement programs and safe, affordable housing for the elderly. After his death at the age of 89, he was eulogized as a humble man who shunned personal praise, preferring instead to shine a spotlight on the problems of the poor and disadvantaged.

During his 21 years as head of the faith-based organization, he founded the Catholic Association for Social Action, Inc., (CASA) to provide low-income housing for senior citizens using federal grant money. Once completed, the community-designed CASA apartments became a model Housing and Urban Development (HUD) project. Considered a pioneer in the field of social work—a career path once dominated by women—Constantine was instrumental in finding sponsors for refugees from Southeast Asia who relocated to Fort Worth. (Courtesy of Joan Kurkowski-Gillen.)

## Heather Reynolds

When Heather Reynolds took over the helm of Catholic Charities Fort Worth (CCFW) at the age of 25, she became one of the youngest chief executive officers of a nonprofit agency in the country.

The Fort Worth native, who earned her undergraduate degree in social work and master's of business administration degree from TCU, oversees more than 275 staff members and a $19-million budget. In 2006, Reynolds launched a $16-million capital campaign to build facilities needed to serve a growing number of needy clients. In 2012, CCFW helped more than 124,000 people.

Because of her innovative thinking and strategic planning to end poverty in the community, she was named TCU's Social Work Alumnae of the Year in 2007. In 2010, the *Fort Worth Business Press* tapped her as one of the paper's "40 under 40" leaders. Reynolds also received the Benemerenti Medal from Pope Benedict XVI—the highest honor given to a layperson in the Catholic Church. (Courtesy of Catholic Charities Fort Worth.)

**Ron Hall**
Ron Hall (left), who attended Riverside Elementary and sang with the Texas Boys Choir, spent years as an art dealer. His life took an unexpected turn in 1998 when he encountered Denver (right), a homeless man making "nothing-to-lose" threats. This incident-turned-friendship is a tale of hope and restoration. Hall recounted his evolution in his *New York Times* bestseller *Same Kind of Different as Me.* His story has helped raise more than $70 million to benefit the less fortunate. (Courtesy of Hall Literary Ventures.)

**Edna Gladney**
For 33 years, Edna Gladney guided the Texas Children's Home and Aid Society, an organization committed to helping orphans and unwed mothers. She rallied for legislation in 1936 to remove the word illegitimate from birth certificates, and in 1951, she helped pass a bill that allowed adopted children to claim the same inheritance rights as birth children. In addition, this law recognized adoptions as a legal, permanent parent-child relationship. (Courtesy of Gladney Center for Adoption.)

**Dr. John Richardson**

Thanks to more than 40 years of wearing the white coat, Dr. John Richardson was certainly "Fort Worth's pediatrician." Not only did he care for countless children in his clinic, but he also served as the on-site pediatrician at the Gladney Center for Adoption for 29 years, participating in approximately 9,000 adoptions.

Dr. Richardson was instrumental, as well, in writing and rallying support to pass the "Baby Moses law" in 1999. This legislation allows birth parents to bring infants to "safe haven" spots instead of being abandoned unsafely or even killed. Texas was the first to pass such a law; since then, all 50 states instituted a version of this statute.

Along with Peggy Bohme, Dr. Richardson cofounded the WARM Place in 1989, an establishment dedicated to aid children as they grieve the loss of a loved one.

Throughout the years, Dr. Richardson served on numerous committees and boards; he believed giving back to the community meant civic participation, financial donation, and excellence in his career. Because of that he received multiple awards, such as the Gold-Headed Cane Award, the Texas Pediatric Society Distinguished Service Award, and the Governor's Volunteer Lonestar Achievement Award, to name a few.

As he looked back on his career, Dr. Richardson hoped he impacted "the general welfare of the children, including their education, safety, and emotional health." (Courtesy of TMS archives.)

### Peggy Bohme

Tragedy can tear a person apart or lead him or her to personal triumph. Peggy Bohme is proof of that. When her 14-year-old son died from bone cancer in 1984, she found support groups for grieving parents but realized there was no place where children, like her daughter, could channel their emotions. With help from her son's pediatrician, Dr. John Richardson, she cofounded the WARM (What About Remembering Me) Place. More than 20 years later, the nonprofit agency continues to offer free grief support services to 2,000 children and their families each year. Bohme and Dr. Richardson remain active on the organization's board of directors.

"Good things can come from the worst tragedies if you're open to it," Bohme said. (Courtesy of the WARM Place.)

**Adelaide Leavens**
Her passion for the Trinity River prompted Adelaide Leavens, a former real estate appraiser, to apply for and earn the executive director's position with Streams and Valleys (SV) in 1998. From that time forward, Leavens guided SV to a fuller realization of its goal: improving the Trinity River for the citizens and visitors of Fort Worth. (Courtesy of Tim Kleuser, Streams and Valleys.)

**Mike Doyle**
Mike Doyle is the president and chief executive officer of Cornerstone Assistance Network, an organization dedicated to directly aiding the poor in Tarrant County and to equipping churches, groups, and other volunteers to impact their community. Due to his humanitarian work, Doyle received the President's Silver Medal and the Kathy Reid Award as well as earned "Executive Director of the Year" in 1998 from the Texas Homeless Network. (Courtesy of Cornerstone Assistance Network.)

### Kent Waldrep

In 1975, Kent Waldrep, a former Texas Christian University tailback, was paralyzed in a football game against the University of Alabama. The life-changing tackle broke his neck but not his spirit. In the years since the injury, Waldrep established two foundations and has raised tens of millions of dollars for nerve regeneration research. He also authored a book, *Fourth and Long*, and helped draft the 1990 Americans with Disabilities Act. The TCU alumnus, who lives in Celina, is founder and president of the Kent Waldrep National Paralysis Foundation based in Dallas.

"Fort Worth has always been a second home for me," he said. (Courtesy of Special Collections, Texas Christian University.)

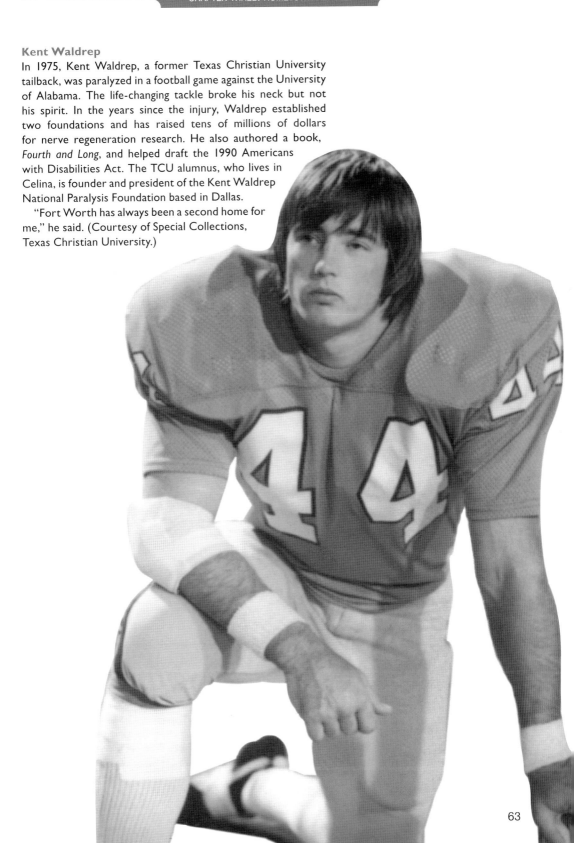

**Rosemary Hayes**
Rosemary Hayes remembers the day she helped unload 40,000 pounds of lettuce and kale from an overturned truck. "It would have been thrown out if someone hadn't called us about it," says the former director of Tarrant County Harvest, an organization that redistributed salvageable food to homeless shelters, soup kitchens, and food pantries.

For her efforts collecting useable produce, bread, and other inventory from area restaurants, bakeries, and grocery stories, Hayes received both the City of Fort Worth Volunteer of the Year Award and the JCPenney Golden Rule Award. The Fort Worth native also volunteered as a "rocking momma" for newborns at Cook Children's Medical Center and organized an auxiliary for the Sisters of St. Mary of Namur. She continues to use her skills in bookkeeping, computer, hospitality, sewing, and monogramming to help the community. (Courtesy of Joan Kurkowski-Gillen.)

**Connie Koehler**
A child dies every four hours in Texas. Connie Koehler wants to ensure they leave this world with dignity, comfort, and love. The retired pediatric nurse, founder of Angel Unaware, is raising money for the first freestanding pediatric hospice and respite care facility for medically fragile children in the Lone Star State. It will be modeled after Helen's House in Oxford, England—the first children's hospice in the world. (Courtesy of Mike Zukerman.)

**Stephen Seleny**
Born in Hungary in 1928, Stephen Seleny (then Istvan Szelenyi) fled an unstable political climate in his home country to Fort Worth, Texas, where he took a job as the assistant director of the Texas Boys Choir. In 1959, he began a school with only a handful of boys in the then vacant St. Ignatius Academy. This school—dedicated to liberal arts education—evolved into Trinity Valley School. (Courtesy of Trinity Valley School.)

**Paulie Ayala**

He is a two-time world champion boxer, but that is not what makes Paulie Ayala exceptional. The owner of the University of Hard Knocks gym on Camp Bowie Boulevard uses his well-crafted training regimen to help people battle Parkinson's disease.

The brain disorder causes tremors, muscle rigidity, and balance issues. Ayala's free "Punching out Parkinson's" training classes help patients build strength and regain control over their bodies using boxing moves. Enthusiasm for the program—modeled after an Indianapolis-based gym—continues to grow as people see results.

Named *Ring Magazine*'s "Fighter of the Year" in 1999, the Fort Worth native wants to give back to his community. The Parkinson's class is becoming crowded, Ayala admits. "But more people are being helped and that's what's important." (Courtesy of Joan Kurkowski-Gillen.)

# CHAPTER FOUR

# Fort Worth Darlings

Graced with winning personalities, charm, and strong work ethics, these goodwill ambassadors epitomize what it means to be a proud Texan—and an even prouder citizen of Cowtown.

The Fort Worth darlings, showcased in this chapter, have shared their gifts, resources, and talents for the greater good. Whether it is a tasty pie baked at a local diner or multimillions donated to improve the pediatric hospital, these past and present icons are part of the homespun fabric of Fort Worth. They are near and dear to the hearts of many. Their generous spirits are respected, admired, and remembered.

Who can forget Ginger Rogers waltzing in the arms of Fred Astaire? Few people know the Hollywood legend grew up here and danced her first steps across the stage of Central (now Paschal) High School.

And when it came to the Fort Worth versus Dallas lifestyle competition, no one boosted Cowtown more than Mack and Madeline Williams. They used the pages of their weekly newspaper to promote the cultural and political advantages found here as well as the colorful pioneer history.

Sports enthusiasts and nonsports lovers alike cheer for Gary Patterson, who not only ushered in a new era of Horned Frog football but also engages in the community in meaningful ways—always exuding a "one of us" sentiment.

Another fan favorite is the Nonna Tata restaurant, where authentic Italian cuisine comes to the table, making patrons feel at home, just like in grandma's kitchen. Pull up a chair or bring one's own (table too)! Everyone feels welcome at Nonna's.

When these legends are mentioned, their names stir up pride and affection in the people of Cowtown. The darlings prove Fort Worth was built around more than just railroads, aviation, and meatpacking plants. The city's strength lies with the people who love it.

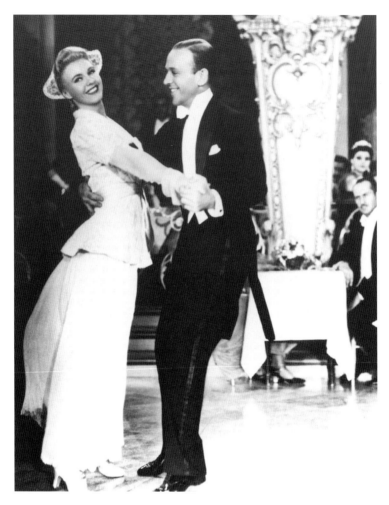

**Ginger Rogers**

Ginger Rogers (left), the celebrated actress, singer, and dancer, enjoyed her first show business success in Fort Worth.

Born in Independence, Missouri, the film star moved to Fort Worth with her mother, Lela, and stepfather, John, where she attended 5th Ward Elementary and Central (renamed R.L. Paschal) High School. Rogers appeared in school theatrical productions like *The Death of St. Denis*, written by her mother, who was also a theater critic for the *Fort Worth Record* newspaper.

Rogers won a major Charleston dance contest held in the Texas Hotel and was awarded her own vaudeville tour as a prize. After moving to New York, the aspiring actress was discovered while performing on Broadway. Her first Hollywood roles were small, but in the film *Gold Diggers of 1933*, fans applauded her performance of the song, "We're in the Money," and she was on her way to stardom.

Rogers was most known for her partnership with Fred Astaire (right). Together, from 1933 to 1939, they made nine romantic musical films: *Flying Down to Rio*, *The Gay Divorcee*, *Roberta*, *Top Hat*, *Follow the Fleet*, *Swing Time*, *Shall We Dance*, *Carefree*, *The Story of Vernon*, *Irene Castle*, and *The Barkleys of Broadway*. The movies lifted the spirits of Depression-era moviegoers with dance steps set to songs composed for them by the greatest songwriters of the day.

The actress later won an Academy Award for her portrayal of a lovelorn career woman in the 1940 film *Kitty Foyle*. At the height of her success, she was the highest paid American woman earning $355,000 a year. (Courtesy of SOHS Library.)

### Mitzi Ann Lucas Riley

Although she entered the world just over two pounds, Mitzi Ann Lucas Riley captured the world's attention from an early age. Born at Harris Medical Hospital in 1928, her doctors did not give Mitzi much hope for life; however, her world champion, horse-riding mother, (Barbara) Tad Lucas, begged to differ. Tad lined a shoebox with cotton, placed her daughter in the "bed," and took her home.

Two months later, Tad showed off a healthy and happy Mitzi at Fort Worth's Southwestern Exposition and Fat Stock Show. Tad rode on horseback while holding a cowboy hat in her lap with tiny Mitzi resting inside.

For a gal who rode a horse before she could walk, Mitzi truly was born for the rodeo. After her mother severely broke her arm at the Chicago's World Fair in 1933, Mitzi began fulfilling her contracts by performing trick riding routines—to great success. By 1934, she was part of the show.

Mitzi worked for more than two decades (never once asking for a job). She participated in Billy Rose's Last Frontier, a Wild West production celebrating the Texas Centennial put on in the heart of Fort Worth. In 1943–1944, Mitzi held the honor of "ranch girl" at Madison Square Garden. She was also a three-time winner of the Cowgirl Race at the Rockingham Park track.

Lanham Riley, a successful calf roper, married Mitzi in 1946. The two made Fort Worth home—that is, when they were not traveling in a station wagon around the country attending rodeos and events. In 1953, Mitzi retired from performing to spend more time with her children.

However, she did not hang up her hat. The couple opened Lanham Riley Training Stables in 1958. Mitzi served on the board of the Rodeo Historical Society and is an honoree at both the National Cowboy Hall of Fame and Fort Worth's own National Cowgirl Hall of Fame. (Courtesy of National Cowgirl Museum and Hall of Fame, Fort Worth, Texas.)

**Steve Murrin**
He has been dubbed the "unofficial" mayor of the Fort Worth Stockyards. Steve Murrin is passionate about preserving the "look and feel" of the Old West in Cowtown. A former city councilman and co-owner of Billy Bob's Texas, he turned his vision and understanding of the area's Western heritage into one of the state's most popular tourist destinations. (Courtesy of Sasha Camacho.)

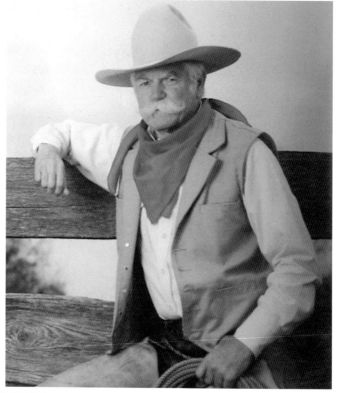

**Iris Bosley**
Born in 1921, Iris Bosley, pictured here dressed in her "work" outfit, served the City of Fort Worth and Log Cabin Village for more than 40 years. The general store on site at the living history museum is named in her honor. Before her decades of greeting and educating visitors at the Log Cabin Village, she worked for many years at Continental National Bank. (Courtesy of City of Fort Worth Log Cabin Village.)

**Harold Taft Jr.**

He was known as "The Dean of TV Meteorologists," but Harold Taft Jr., the first television meteorologist west of the Mississippi River, was more than just a television personality who talked about the weather. He was a trusted icon invited into North Texas homes every evening. If Harold Taft said it was going to rain, in most cases, it did.

After studying meteorology at the University of Chicago, the Oklahoma native joined the Army Air Corps during World War II and was part of Gen. Dwight D. Eisenhower's staff during D-Day. He later graduated from Phillips University and went to work for American Airlines as a staff meteorologist. While employed at the carrier, Taft pitched the idea of an evening weather program to WBAP-TV, which later became KXAS. The first show aired on October 31, 1946, with Taft as chief meteorologist—a title he maintained during his almost 42 years in broadcasting.

When Delta flight 191 crashed at DFW International Airport on August 2, 1985, Taft identified the cause as wind shear and went on to testify about the weather phenomenon at hearings. His no-nonsense style of weather reporting continues to set the standard for others to follow. (Courtesy of KXAS/NBC 5.)

### John Byron Nelson Jr.

At age 12, Byron Nelson caddied at Glen Garden Country Club in southwest Fort Worth—the start of the golfing icon's career. In 1934, Nelson launched his professional tour, winning his first major title in 1937. The apex of his golf game occurred in 1945 when he won 18 tournaments, 11 of which were consecutive.

Although he retired at age 34, Nelson's contribution to the game of golf still exists. He was the first professional golfer to be honored as the namesake of a PGA tournament. Nelson received numerous accolades, including the Bob Jones Award, the PGA Tour Lifetime Achievement Award, and the Congressional Gold Medal.

Yet, his kind demeanor and gracious attitude earned him more respect than even his golden golf swing. Dubbed "Lord Byron" in honor of his gentlemanly manners, Nelson had a caring nature and had made many humanitarian contributions to Cowtown. (Courtesy of the Byron Nelson Jr. estate.)

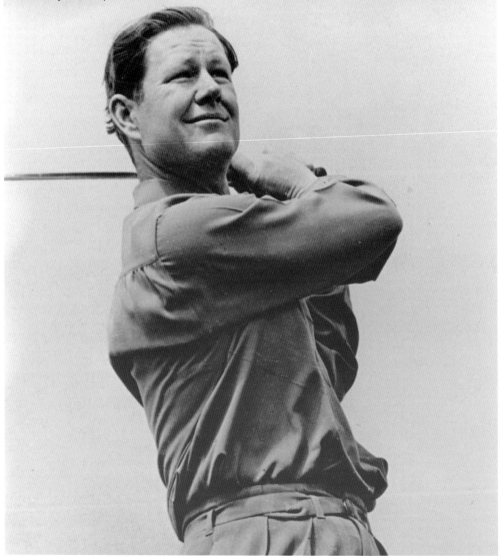

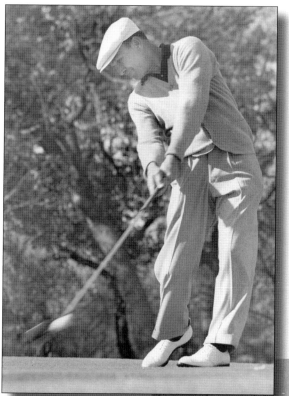

### Ben Hogan

Ben Hogan moved with his family to Fort Worth when he was a small child. By the age of 12, he caddied and started honing his golfing game. In his early twenties, Hogan joined the professional golf tour for good, quickly earning the biggest paychecks in golf at that time (1940–1942.)

After serving in the Army during World War II, Hogan came back to the golf circuit to win his first tournament in 1946. Then, after a life-threatening car accident in 1949, Hogan returned to golf again to continue—miraculously—his winning streak. During the infamous 1953 season, Hogan made history when he won five out of six tournaments, including the coveted Masters, US Open, and British Open honors. During his career, he celebrated 64 tournament victories and 9 major championships. (Both courtesy of the Ben Hogan family.)

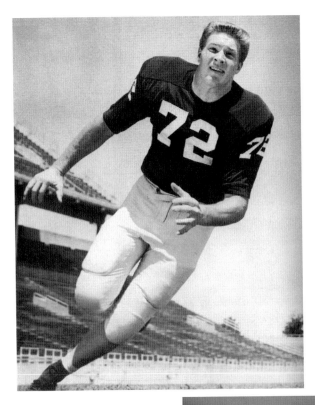

**Bob Lilly**
Bob Lilly attended Texas Christian University on a football scholarship. This was a grant well-earned, as Lilly went on to be a two-time All-Southwest Conference player and an All-America pick. In 1961, the Dallas Cowboys drafted Lilly as the team's first pick—ever. He played 14 seasons in the NFL and entered the Pro Football Hall of Fame in 1980. (Courtesy of Special Collections, Texas Christian University.)

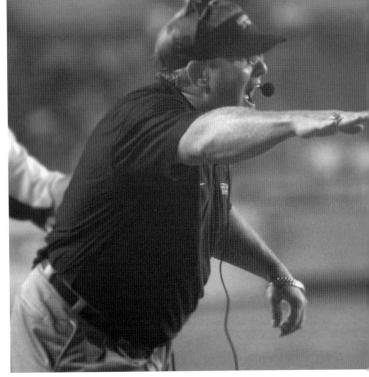

**Gary Patterson**
In December 2000, Gary Patterson became head coach for the Texas Christian University football team. He is credited for ushering in the new wave of "winning," thanks to back-to-back BCS bowl appearances and racking up more wins than any coach in TCU's history. In 2012, Patterson led the pigskin squad into Big 12 play. (Courtesy of Special Collections, Texas Christian University.)

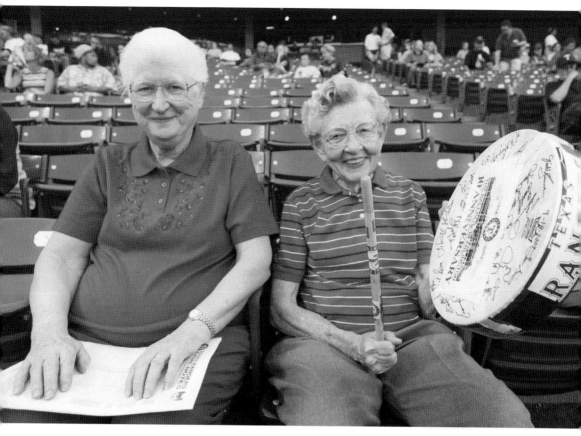

### Texas Ranger Nuns, Sisters Frances and Maggie

Win or lose, no one ever doubted their loyalty to the Texas Rangers. Sr. Frances Evans (right) and Sr. Maggie Hession (left) sat behind home plate and cheered for their favorite team since the baseball club moved from Washington, DC, to Arlington in 1972.

The sisters' fascination with Texas baseball started when both were working at the now closed St. Joseph Hospital. Sister Maggie, a nurse, was in charge of the surgical unit. After receiving her master's degree in social work from Tulane University, Sister Frances started the first hospital-based social service department in the area.

When the Rangers played their first game in Arlington on April 15, 1972, Sister Frances asked a friend, who worked near the box office, to pick up a $10 ticket for her. She was instantly smitten by the excitement of big-league baseball.

Over the years, the sisters became the unofficial cheerleaders for the team. Known for using a small drum to rev up the crowd, they attended a Ranger's fantasy camp and traveled to Yankee Stadium where they were pictured with Ranger players. When the ballpark in Arlington opened in 1994, Sisters Frances and Maggie were the first fans through the turnstiles. Members of the Congregation of the Sisters of Charity of the Incarnate Word, the ardent baseball fans were in the stands to watch the Texas Rangers play for the World Series title in 2011.

"We always believed it would happen. We just didn't know it would take this long," Sister Frances said at the time.

They remained a fixture at every Ranger home game until Sister Maggie was diagnosed with Alzheimer's disease and could not cope with the crowds and noise. In July 2013, the Rangers paid tribute to Sister Frances—the team's number one fan—on her 86th birthday. (Courtesy of John F. Rhodes, *Dallas Morning News*.)

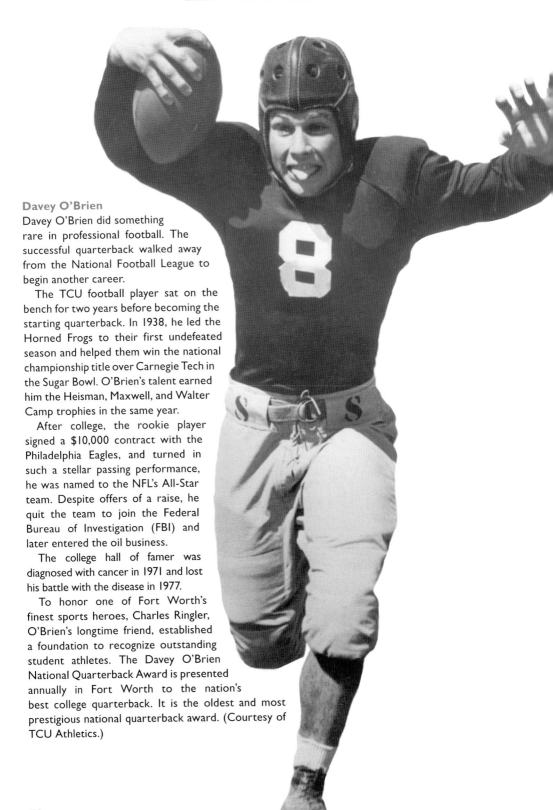

**Davey O'Brien**

Davey O'Brien did something rare in professional football. The successful quarterback walked away from the National Football League to begin another career.

The TCU football player sat on the bench for two years before becoming the starting quarterback. In 1938, he led the Horned Frogs to their first undefeated season and helped them win the national championship title over Carnegie Tech in the Sugar Bowl. O'Brien's talent earned him the Heisman, Maxwell, and Walter Camp trophies in the same year.

After college, the rookie player signed a $10,000 contract with the Philadelphia Eagles, and turned in such a stellar passing performance, he was named to the NFL's All-Star team. Despite offers of a raise, he quit the team to join the Federal Bureau of Investigation (FBI) and later entered the oil business.

The college hall of famer was diagnosed with cancer in 1971 and lost his battle with the disease in 1977.

To honor one of Fort Worth's finest sports heroes, Charles Ringler, O'Brien's longtime friend, established a foundation to recognize outstanding student athletes. The Davey O'Brien National Quarterback Award is presented annually in Fort Worth to the nation's best college quarterback. It is the oldest and most prestigious national quarterback award. (Courtesy of TCU Athletics.)

**John Peyton Elder**

The North Side Junior High School became J.P. Elder Middle School in 1935. John Peyton Elder earned this honor due to his civic contributions and service on the board of education for 10 years. In 1937, John Peyton Elder retired from the Swift & Company where he worked as an executive. Two years after his "retirement," Elder became the right-of-way agent for the county. (Courtesy of Billy W. Sills Center for Archives, FWISD.)

**Charlie and Sue McCafferty**

Committed to preserving Cowtown's stockyards and other northern Fort Worth landmarks, Charlie and Sue McCafferty established the North Fort Worth Historical Society (NFWHS) in 1976. Sue served as president for 25 years. She oversaw the opening of the first visitors' center and the placement of historical markers throughout the historic district. The NFWHS continues to preserve and proclaim Fort Worth's prized history. (Courtesy of NFWHS.)

**Doyle and Libby Willis**

Historic preservation brought this couple together. When Libby Willis came to Fort Worth as director of the local National Trust Preservation office, she met Doyle Willis Jr., son of longtime legislator Doyle Willis Sr., who was at the time the chairman of the board for the Historical Preservation Council of Tarrant County. Two years later, they became husband and wife. Doyle worked as an attorney, a judge, and the Texas Assistant Attorney General until 2003, when he entered semiretirement. Libby spent many years with the National Trust, started Preservation Texas, and worked at Historic Fort Worth before commencing her preservation consulting service in 2001.

Libby considers helping the Oak Hurst neighborhood gain landmarks status as her greatest achievement thus far.

The couple enjoys all Fort Worth offers, especially the vibrant arts culture, and hopes the historical integrity of the community continues to impact and shape the future. (Courtesy of the Willis family.)

## Sid W. Richardson

An oilman from the start, Sid Richardson's luck waxed and waned during the early 1900s until the 1930s, when a small investment in the Keystone Field paid big dividends. A man of exceptional fortune, Richardson managed his wealth and business with straightforward Texas candor.

He collected artwork from Frederic Remington and Charles Russell and raised quarter horses and cattle on his ranches.

After his death in 1959, the Sid W. Richardson Foundation began providing significant grants in support of "programs in education, health, and human services that could play a role in 'helping people help themselves.'" (Courtesy of Del Mar Thoroughbred Club.)

## Perry and Nancy Lee Bass

When Perry Bass benefited from his uncle Sid Richardson's oil fortunes, he turned the multimillion-dollar fortune into much more. In 1960, Bass established the Bass Brothers Enterprises to invest, allocate, and manage the family's growing interests. Bass proved to be an astute businessman just like his uncle.

Nancy Lee (Muse) Bass, a Fort Worth native and graduate of Central High School (now R.L. Paschal), married Perry in 1941.

Throughout the couple's 65-year marriage, they invested their lives, love, and funds into Fort Worth. A main performance venue, the Nancy Lee & Perry R. Bass Performance Hall, named in their honor, rests in the midst of downtown, an area the Bass family helped revitalize.

Nancy Lee was also involved with many organizations, like the Junior League, Fort Worth Garden Club, and First United Methodist Church. She served as vice president and director of the Sid W. Richardson Foundation; worked on the board of the Modern Art Museum of Fort Worth; and contributed to the advisory board for the Van Cliburn International Piano Competition.

In more ways than can be expressed here, Perry and Nancy Lee Bass nurtured and encouraged Fort Worth to embrace the arts, to improve education, and to enjoy life.

Perhaps, their greatest role was parenthood, raising four boys—Sid, Edward, Robert, and Lee—to also become wise, compassionate, and generous Cowtown citizens. (Courtesy of *Fort Worth Star-Telegram*, Special Collections, The University of Texas at Arlington Library, Arlington, Texas.)

**The Bass Brothers**

Born to oil tycoon and Fort Worth philanthropists Perry and Nancy Lee Bass, the Bass brothers—Sid Richardson, Edward Perry (pictured in the front, age 11), Robert Muse (pictured in the back, age 8), and Lee Marshall—continued their family's legacy of business acumen and altruism.

Perry Bass trained his boys to be part of the business early on. In 1968, Sid assumed directorship of the Bass conglomerate. Edward served for many years as president and member of the board of directors for the Sid W. Richardson Foundation. Robert, who ventured out on his own, created the lucrative organizations Keystone, Inc., and Aerion Corporation. Lee assisted the Texas Parks and Wildlife Department for many years.

The brothers also champion and support numerous civic and charitable causes, donating millions to the betterment of Fort Worth and other cities. (Courtesy of *Fort Worth Star-Telegram*, Special Collections, The University of Texas at Arlington Library, Arlington, Texas.)

### Amon G. Carter Sr.

An entire book could not contain the life and times of Amon G. Carter, one of Fort Worth's most beloved entrepreneurs and cowboys. His legacy continues to impact the evolution of Cowtown.

In 1905, Amon Carter moved to Fort Worth to take an advertising salesman job. In 1908, Carter gained financial support to merge two Fort Worth newspapers, thus launching the *Fort Worth Star-Telegram* on January 1, 1909. Fourteen years later, he took over as publisher and president of the media outlet. However, his endeavors did not stop with print. Carter founded the WBAP radio station and WBAP-TV, the first television station in Texas, broadcasting for the Southwest region.

Carter always dreamed big, but he always dreamed local, too. The youngest president of the Fort Worth Chamber of Commerce, Carter campaigned for numerous industries—from oil companies to transportation corporations to arts organizations—to take residence in Tarrant County.

His interest in aviation and cutting-edge developments in engineering made him a perfect fit for his role as director and part owner of American Airways, which eventually became American Airlines presently based in Fort Worth.

His business acumen was only bested by his generosity, especially in areas of expansion and cultural growth. The Amon G. Carter Foundation, established in 1945, supports area organizations dedicated to the arts and education. Carter himself served as president of the Fort Worth Club for 35 years and worked as director of the Southwest Exposition and Fat Stock Show, in addition to many other positions with boards, committees, and Fort Worth projects.

In light of his exceptional life, Carter received many accolades, such as the Ambassador of Goodwill, the Exceptional Service Medal, and the Frank M. Hawks Award.

Carter died on June 23, 1955, in Fort Worth. In his will, he directed his heirs to create the Amon Carter Museum of American Art using his personal collections of Frederic Remington and Charles M. Russell paintings and sculptures. (Courtesy of *Fort Worth Star-Telegram*, Special Collections, The University of Texas at Arlington Library, Arlington, Texas.)

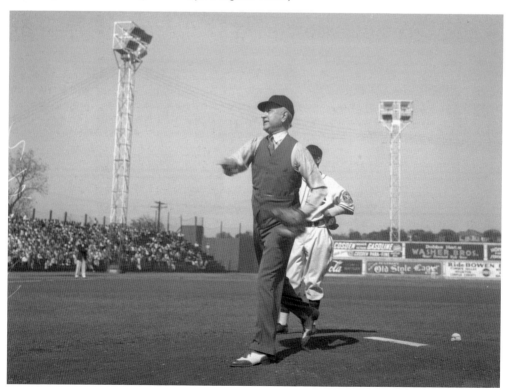

**Ruth Carter Stevenson**

Daughter of Amon G. Carter Sr., Ruth Carter Stevenson's legacy is as vibrant and varied as her father's. At 26, Stevenson earned a spot on the Fort Worth Art Association's board. Shortly thereafter she succeeded in bringing an American art exhibition to Fort Worth—a first of its kind. Through her work with the Junior League, she organized an arts education curriculum for Fort Worth elementary students.

Stevenson's passion for the arts and her art education equipped her to fulfill her father's directive to open a museum dedicated to American art; a feat she completed in 1961 with the opening of the Amon Carter Museum of American Art. She served on its board for more than 50 years.

The previous year, in 1960, Stevenson joined the Fort Worth City Art Commission, an organization she served for 23 years. In 1963, she created the Arts Council of Fort Worth and Tarrant County. After the death of her brother in 1982, Stevenson became the president of the Amon G. Carter Foundation.

Ruth Carter Stevenson—a Fort Worth treasure—passed away in 2013. (Courtesy of *Fort Worth Star-Telegram*, Special Collections, The University of Texas at Arlington Library, Arlington, Texas.)

**Bayard H. Friedman**
Born in 1926, Bayard H. Friedman was a noted and successful Cowtown businessman. While his career accomplishments are many, Friedman is most revered as a philanthropic community leader, especially ardent in his support of the arts. He was a founding board member of the Performing Arts Fort Worth and worked extensively to raise support for the Nancy Lee & Perry R. Bass Performance Hall. (Courtesy of the Friedman family.)

**Preston Geren**
Preston M. Geren Jr. believed the greatest gift a person could receive was an education. The Texas A&M graduate sponsored seven scholarships at his alma mater where he was a distinguished alumnus. After serving in World War II, he joined his father's firm, Preston M. Geren Architects & Engineers, and was instrumental in building it into one of the largest firms in Texas. Construction projects included Texas's major universities and the Kimbell Art Museum. (Courtesy of the Geren family.)

**Kay and Velma Kimbell**

In 1936, Kay and Velma Kimbell, along with Dr. and Mrs. Coleman, created the Kimbell Art Foundation, which now owns and manages the Kimbell Art Museum.

The couple married in 1910 in Durant, Oklahoma, but moved to Sherman, Texas, two years later when Kay founded the Beatrice Milling Company (later the Kimbell Milling Company). In 1924, the Kimbells transitioned the company to the growing Fort Worth community.

In addition to the success of the milling business, which resulted in more than 70 various companies, the Kimbells were savvy international art collectors. This interest in artwork fueled their passion for the foundation.

Upon Kay's death in 1964, the Kimbell Art Foundation received the bulk of his fortune and artwork with the directive to create a first-class museum for Fort Worth and Texas. Velma guided the development of the museum until it opened in 1972 and remained involved in the many programs and services of the gallery. (Both courtesy of Kimbell Museum.)

## Mack and Madeline Williams

Mack Williams was born in New Jersey, but he liked to tell people his March 2 birthday—which coincides with Texas Independence Day—made him a true Texan. A seasoned newspaper reporter who covered the White House during Pres. Franklin Roosevelt's administration, Williams met and married fellow journalist Madeline Crimmins, a Fort Worth native, when both worked at the *Fort Worth Star-Telegram*.

In August 1970, they purchased a small, weekly newspaper and converted it into a county-wide publication that catered to political, business, and legal interests. The *News-Tribune* was the first weekly newspaper in the United States to become a member of the Associated Press.

While a reporter for the *Fort Worth Star-Telegram*, Mack Williams wrote articles about the early settlers of the city for a 1949 special edition of the paper celebrating Fort Worth's centennial. He later parlayed some of that material into a *News-Tribune* column titled "In Old Fort Worth." Some of his stories were organized into a book, *In Old Fort Worth*, published in 1977. The couple sold the *News-Tribune* in February 1986.

Throughout their long, storied careers as journalists, Mack and Madeline Williams used their writing skills and professional contacts to champion Fort Worth's pioneer heritage, thriving cultural district, and quality of life. (Courtesy of Tom Williams.)

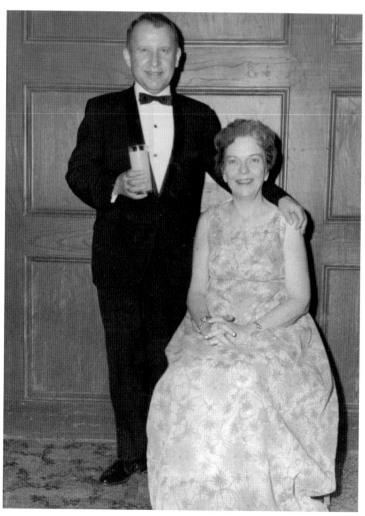

**Bob Schieffer**
No matter where his award-winning journalism career took him, Fort Worth has always been home to Bob Schieffer. He attended North Side High School and TCU. His first journalism job at KXOL paid $1 per hour. Yet, by 1965, Schieffer made strides in his career as the first Texas newspaper reporter working from Vietnam. His job at the *Fort Worth Star-Telegram* then transitioned to Channel 5. From there, Schieffer landed a job with CBS covering political news, and the rest is history.

Throughout the years, Schieffer received numerous awards, was honored as a *New York Times* best-selling author, moderated three presidential debates, anchored *CBS Evening News*, and hosted the highly acclaimed *Face the Nation*.

Schieffer, who covered the JFK assassination, Watergate, and 9/11, says of all his achievements and honors, the most meaningful is the Schieffer School of Journalism—the TCU program named in his honor. (Courtesy of Special Collections, Texas Christian University.)

### Tiffin Hall

Tiffin Hall gave Fort Worth one of its most popular restaurants. The Missouri native, who moved to Fort Worth in 1920, opened the Mexican Inn Café inside a three-story building at the corner of Fifth and Commerce Streets. Although fires damaged the original Mexican Inn Café twice, the restaurant continued to welcome customers for decades. Opened in 1936, the downtown eatery finally closed and was demolished in 2005. (Courtesy of Kevin Guyton.)

### Nonna Tata

Named after her grandmother, chef and owner Donatella Trotti opened Nonna Tata's on Fort Worth's Magnolia Avenue in 2009. Since then, the demand for authentic Northern Italian cuisine prompted Trotti to serve lunch and dinner. The trattoria only boasts 500 square feet of dining space with an outdoor patio; yet the BYOB rule, friendly atmosphere, and amazing food draw perpetual crowds. (Courtesy of Emily White Youree.)

**Jo and Pete Bonds**

Jo and Pete Bonds (sitting) may own the only Texas ranch that produces cattle and ballerinas.

The Bonds Ranch operation grazes cattle in 27 Texas counties and 13 states, extending from the Rio Grande to Canada.

It is also home to the Dance Ranch—a school where aspiring young dancers learn how to plié and shuffle step. Jo Bonds, a TCU fine arts graduate, added the studio onto the family's ranch house in the mid-1970s and has welcomed ballet, tap, and jazz students to her home-based business ever since.

Her husband, Pete, who earned ranch management and business degrees from TCU, continues to grow the family's ranch, purchased in 1933 by his grandfather, P.R. "Bob" Bonds. *Beef Magazine* named Pete Bonds "Beef Stocker of the Year" in 2011.

Although the family has sold parcels of acreage to housing developers, the ranch remains one of the largest single blocks of land in Tarrant County. Constantly growing and innovating, the Bonds Ranch is part of the Non-Hormone Treated Cattle (NHTC) program that enables export to Europe. The couple has three daughters, Missy, Bonnie Anderson, and April (standing).

With more ranchers selling out to land developers, the Bonds family members consider their spread a living part of Texas history. (Courtesy of Jo Bonds.)

## Paris Coffee Shop

Gregory K. Smith purchased the Paris Coffee Shop from Vic Paris in 1926. At that time, the counter-only café was located on the "edge of town" at its Magnolia Avenue address.

By 1965, when Smith sold the restaurant to his son Mike Smith, the establishment had grown in size and popularity. The counter and dining area hosted customers for breakfast, lunch, and dinner.

The lure of the Paris Coffee Shop had little to do with coffee—and certainly not the kind of coffee served in a fancy container and sleeve. The tradition of home-cooked food and personal service—an old-fashioned philosophy—brought (and brings!) customers back again and again.

Five years after he bought the business, the younger Smith closed the dinner service, focusing only on breakfast and lunch . . . and pie. The pie served at Paris Coffee Shop is the stuff of sweet dreams, even gaining a visit from Food Network's Duff Goldman who tasted treats for the *Sugar High* show.

One thing is for certain; there is always a crowd—and sometimes a line—at the Paris Coffee Shop. Smith routinely waits by the door, greeting diners and helping them find a seat. He chats with longtime patrons, asking about family, ailments, and the latest news. Paris Coffee Shop is the hometown, good-food dive Fort Worth is lucky enough to call its own. (Both courtesy of Emily White Youree.)

# CHAPTER FIVE

# Innovators

Innovators have big plans, bigger ideas, and the determination to make them work. They push the boundaries of mediocrity and see something better. Their inventiveness, teamed with hard work, creates products and businesses that benefit everyone.

Fort Worth is blessed to be home to visionaries like Elizabeth Shaw—a widow who pulled up stakes in Indiana when she saw opportunity in Texas. She helped her five sons establish Shaw Brothers Dairy in 1892 and watched it grow to become the largest dairy in Texas.

Ninnie Baird lived a similar story. When her husband died in 1911 and she had young mouths to feed, the resourceful mom turned her knack for baking tasty treats into a successful company. A loaf of Mrs. Baird's bread is still a staple in Fort Worth homes today.

Thanks to Holt Hickman, people can take a stroll through the stockyards and imagine what Fort Worth was like when Ninnie Baird delivered her bread to customers in a horse and carriage. The committed preservationist saved the historic integrity of the Fort Worth Stockyards. At the same time, his business career has been about innovation and the future.

And when considering the future of business innovation, the M.J. Neeley School of Business at TCU comes to mind. Savvy with numbers and guiding companies in the right direction, M.J. Neeley contributed to the fabric of Fort Worth through his corporate expertise and philanthropy. The school that now bears his name is a great testament to his legacy—a commitment to instruct and foster the greatest business minds in the country.

Helen Painter started her real estate business with a promise to be the best, not necessarily the biggest. Her progressive and inventive methods propelled her into leadership positions from a local to national level. Painter, who "sold Fort Worth," helped usher in modern practices in real estate.

Since its beginnings as a dusty, military outpost, Fort Worth has grown and prospered thanks to the aspirations and dreams of innovators. What is next for Cowtown? The possibilities are as endless as the Texas sky.

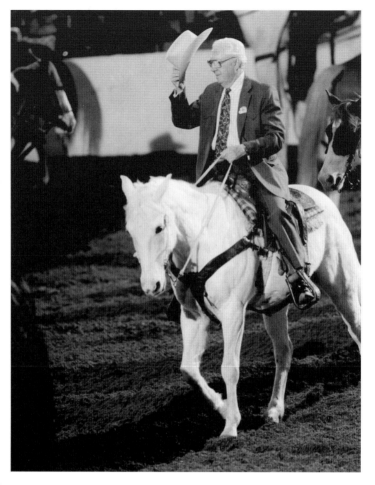

### John Justin Jr.

John Justin Jr. put his personal shine on the boot industry in Fort Worth. The iconic Fort Worth businessman is the grandson of H.J. Justin, a boot repairman, who in 1879 began crafting and repairing footwear from a barbershop in Spanish Fort, Texas. Early customers were cowboys working cattle along the Chisholm Trail.

To market the handmade boots in a larger city, the entrepreneur eventually moved his company to Nocona, Texas, in 1889. Sons John, Earl, and Avis Justin took over the family business after their father's death in 1918 and moved the company headquarters to Fort Worth seven years later.

John Justin Jr. purchased controlling interest in the company in 1950 and built the business into a national firm through innovation and acquiring competitors. He is credited with developing the Roper—a boot favored by rodeo riders that became one of the most popular Western footwear styles. In August 2000, Berkshire Hathaway purchased Justin Boots.

While growing his business, Justin Jr. found time to help Fort Worth develop and prosper. He was a member of the Fort Worth City Council from 1959 to 1961 and served as mayor from 1961 to 1963. A longtime chairman of the Fort Worth Stock Show and Rodeo, he spearheaded the drive to build an equestrian center at the Will Rogers complex, which now bears his name. Justin Jr. was also an ardent booster of TCU, and the school named the athletic center in his honor.

Recipient of many awards including induction into the National Cowboy Hall of Fame and the Texas Business Hall of Fame, Justin Jr.'s most lasting contribution to Fort Worth was his drive to promote the city's distinct place in Western history. (Courtesy of Justin Brands, Inc.)

### Theo Yordanoff

A native of Skopje, Yugoslavia, Theo Yordanoff is remembered for introducing calf fries to the menu at Theo's Saddle & Sirloin Inn in the stockyards. Yordanoff would get the calf testicles free of charge from the nearby packinghouses and stuff them into sandwiches for 15¢. The menu item was considered a cheap and nourishing meal for the men who worked in the nearby meatpacking plants. (Courtesy of Riscky's Barbeque.)

### Riscky's Barbeque

Fort Worth met Joe Riscky in 1911. Sixteen years later, this Polish immigrant and his wife, Mary Bunkervitch, opened Riscky's Grocery & Market in the north part of town. The couple's homemade barbecue lunch quickly became a cult classic. Generations later, Riscky's Barbeque is still a family-run business and Fort Worth tradition. The Riscky family now offers eight restaurants and full-service catering. (Courtesy of Riscky's Barbeque.)

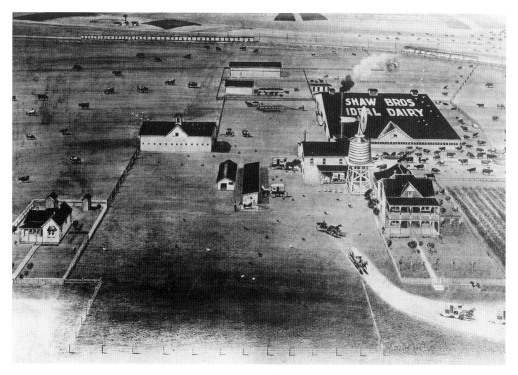

### Shaw Brothers Dairy

Elizabeth Shaw was a determined and feisty pioneer. When her husband, Andrew Jackson Shaw, died in Montgomery, Indiana, she followed the advice of a priest who had visited Texas and saw opportunity in the Lone Star State.

In 1889, she sold her horses, cattle, property, and possessions at a public auction and climbed onto a buckboard with her two daughters and five sons for the trip to Terra Haute, Indiana. When they arrived at the bustling center for commerce and transportation, they boarded a train and headed south.

From there, the Shaws settled near the intersection of Broadway and South Main Street in Fort Worth and established the Shaw Brothers Dairy in 1892. It grew to become the largest dairy farm in Texas with two dairies for milking cows and a large creamery located on South Calhoun Street. The plant produced milk, cream, butter, cottage cheese, and ice cream. In addition to a large local trade, the business also shipped dairy products to adjoining towns. The creamery was sold to Dairyland in 1929 and later became known as Foremost Dairy.

Many stained-glass windows, bearing the names of Shaw family members, can be found at Our Mother of Mercy Church. A large stain-glass window at St. Mary the Assumption Church on Magnolia Street was donated by Gus and William Shaw—the two principal owners of Shaw Brothers.

Today, the George C. Clarke Elementary School is located on the site where dairy cows once roamed. Shaw Street in southwest Fort Worth remains a lasting tribute to the pioneer dairy farmers. (Courtesy of Doug Sutherland.)

**Ninia Lilla "Ninnie" Baird**

When the family breadwinner died, Ninnie Baird baked bread to feed her family. The widow's ingenuity, perseverance, and hard work made her the founder of the Mrs. Baird's Company, the largest independent bakery in the United States.

The family's rags-to-riches story began in 1901 when Ninnie and William Baird moved to Fort Worth from Tennessee. An entrepreneur, William introduced the first steam popcorn machine to the city and used profits from the street corner venture to open a restaurant. His wife, Ninnie, who supplied the diner with baked goods, developed a reputation for producing tasty breads, cakes, and pies.

As her husband's health failed, Ninnie decided her best source of income was baking bread for sale. She sold the restaurant and started Mrs. Baird's Bread in 1908. When William Baird died in 1911, the Baird children helped run the fledgling venture. Ninnie's sons used their bicycles to deliver loaves to customers.

In 1915, Mrs. Baird's Bread purchased a used commercial oven from the Metropolitan Hotel for $75. Ninnie handed more than $25 in cash and paid the balance in bread and rolls.

With the capacity to bake 40 loaves at once, the business grew. A horse and wagon replaced bicycle deliveries, and the company opened an expanded bakery in 1918. Ninnie baked bread 16 hours a day but would occasionally ride with her son Hoyt in the delivery carriage. Between 1919 and 1928, the bakery was enlarged nine times.

By the end of World War II, Mrs. Baird's was selling bread across Texas.

When Ninnie Baird died in 1961, the company had grown to nine plants with more than 2,500 employees. The Ninnie L. Baird Foundation continues her legacy of improving the lives of children through family preservation, education, and nutrition.

Bimbo Bakeries USA purchased Mrs. Baird's in 1998. (Courtesy of Dr. Craig Baird.)

**Chef Tim Love**
Acclaimed chef Tim Love brought his creative and tasty take on Western cuisine to Fort Worth in 2000 when he opened Lonesome Dove Western Bistro. He then purchased the White Elephant Saloon. Two more restaurants followed with the creation of the Love Shack and the Woodshed Smokehouse. Love parlayed his passion for food and his affection for football by becoming the lone food service provider at TCU's Amon G. Carter Stadium in 2013. (Courtesy of Tim Love.)

**Chris Farkas**
Chris Farkas gave Fort Worth its favorite pizza. In 1968, Farkas and his father bought the original Mama's Pizza on Rosedale from Ed Stebbins, who used his Italian mother's recipe to create the store's signature garlic butter crust. The new owners opened a second location on Berry Street and the eatery soon became synonymous with TCU. A devoted alumnus, Farkas decorated the store with an eclectic mix of TCU memorabilia. (Courtesy of Jordan Scott.)

### The Garcia-Lancarte Legacy

Joe T. Garcia started his maiden restaurant, Joe T's Barbecue, in 1935 on Commerce Street. The customers lined up, but it was not for barbecue. Everyone wanted more enchiladas and tacos—cooked by Joe's wife, Jessie. Thus, the Garcias wisely changed the name and focus of the eatery. Joe T. Garcia's Mexican Restaurant—or as the locals call it, Joe T's—became a Cowtown legend and rite of passage.

Generations later, the Garcia business thrives. The family also opened Esperanza's, a bakery and café, in multiple locations. Chef Lanny Lancarte, Garcia's grandson, perfected his culinary skills through traditional education and through years working along side his family in the restaurant industry. He launched Lanny's Alta Cocina Mexicana in 2005, a fine-dining establishment that serves Mediterranean-inspired dishes using Mexican ingredients. (Above, courtesy of Emily White Youree; below, courtesy of Chef Lanny Lancarte.)

### The Original Mexican Eats Café

The Original Mexican Eats Café is Fort Worth's oldest restaurant. Opened in 1926 by the Piñeda family, the establishment has served five generations. One of the most notable customers was a former president. During the 1930s, FDR would dine at the restaurant with son Elliot, who lived in the area.

In 1936, the owners created the "Roosevelt Special" in honor of the president's favorite meal. The plate combines a fried-to-order chalupa shell topped with beans and cheese, a crispy beef taco, and a cheese enchilada in chili con carne topped with two sunny-side up eggs. It remains the restaurant's signature dish. (Courtesy of Joan Kurkowski-Gillen.)

**Paul Perrone
and Horace Park**
Paul Perrone (left) and
Horace Park (right)
purchased Swan Drug
pharmacy in 1952. They
changed the name to
Perrone & Park Pharmacy.
Thanks to booming business,
the pharmacy changed
locations to its present
spot on Benbrook Highway.
In 1975, Park directed his
attention full-time to the
new store in Western Hills,
while Perrone remained at
the original facility. Decades
later, Perrone Pharmacy
is one of the largest
(and last) independent
retail pharmacies in
Texas. (Courtesy of
Perrone Pharmacy.)

**Hal Brown**
A former TCU football player
and Cowtown native, Hal Brown
owns and publishes *Fort Worth,
Texas: The City's Magazine*. Not
only does the magazine cover
the city's happenings, but it gives
back, sponsoring nearly 150
community fundraising events
yearly. Brown also serves on boards
and committees, such as the TCU
Letterman's Association and the
A.J. and Jessie Duncan Foundation.
(Courtesy of *Fort Worth,
Texas* magazine.)

99

**Joe Kuban**
Six weeks before he died of Lou Gehrig's disease, Dr. Joe Kuban, returned to Nolan Catholic High School—where he taught for 37 years—to watch students plant an evergreen in his honor. It was an appropriate tribute for an educator who founded the nation's longest-running high school ecology program. Recipient of the Jane Goodall Ecology Award, Dr. Kuban taught students to be critical thinkers and stewards of the environment long before it became fashionable. (Courtesy of Nolan Catholic High School.)

**Holt Hickman**
Many people wanted to preserve the historic integrity of the Fort Worth Stockyards. Holt Hickman had the vision and resources to make it happen. The businessman turned the property and buildings he owns into the successful Stockyards Station. The 85,000-square-foot complex once housed sheep and hog pens but is now home to an eclectic mix of souvenir shops, Western clothing stores, and restaurants. (Courtesy of Hickman Investments, Ltd.)

### John Peter Smith

John Peter Smith started the first Fort Worth school. After fighting in the Civil War, Smith commenced his law and real estate career, amassing a fortune. He organized the stockyards, moved the county seat, helped create a school system, served as mayor, and instituted a water department. Yet, this "father of Fort Worth" is most known for his land donation in 1877—the lot where John Peter Smith Hospital now sits. (Courtesy of Emily White Youree.)

### M.J. Neeley

M.J. Neeley's Cowtown career started when he worked as a bookkeeper at Hobbs Manufacturing. From that point, he went on to steer more than 30 companies to financial success. In 1946, Neeley joined the board of trustees at TCU and later served as chairman. The business department took on his name in 1967, becoming a premiere business school. The Neeleys also started the Starpoint School—an educational facility for special needs children. (Courtesy of the M.J. Neeley School of Business at TCU.)

### Adlai McMilan Pate Sr.

From the meager start in a tin barn, Adlai McMilan Pate Sr., along with his partner Carl Wollner, created a multimillion-dollar, worldwide conglomerate of companies. Known first as Panther Oil and Grease Manufacturing, Pate's children and grandchildren continue to run the business, now named the Texas Refinery Corporation.

Pate's name also adorns a Fort Worth elementary school—a testament to Pate's belief in education and philanthropy. (Courtesy of Texas Refinery Corporation.)

### Helen Painter

Helen Painter Realtors began when Fort Worth legend Helen Painter adopted her progressive business philosophy to the real estate sector. She sold Cowtown properties for more than 40 years—and her legacy lives on with this family-run business. In 1966, Painter became the first female president of the Fort Worth Real Estate Board and went on to hold other positions at the local, state, and national level with the National Association of Realtors. She was also influential in organizing the area's Multiple Listing Service. (Courtesy of Emily White Youree.)

**John J. Hernandez**

Ask any one of Jeanette and John J. Hernandez's eight children what their father stressed most as they grew up and the answer is education.

"Dad always said no one could take our education away from us," said daughter Teresa Montes. "A strong work ethic is something he taught by example."

But the founder of John Sons Press did not just want a better life for his own offspring. He also paved the way for others to succeed.

In 2000, the successful businessman received the Ohtli Award from the Mexican Ministry of Foreign Affairs for his lifetime of service to the Hispanic community. The Ohtli award is the highest honor given to people of Mexican descent living outside Mexico who ease the assimilation process for future generations.

"Paving the way for others to follow, Mr. Hernandez helped tear down the walls of discrimination," Congresswoman Kay Granger said in remarks made before Congress. "He has always been a crusader for the betterment of the Hispanic community."

Hernandez serves as chairman of the Fort Worth Hispanic Chamber of Commerce and was honored with the Silver Beaver Award for his work as an outstanding Boy Scout leader of Troop No. 315 at All Saints Catholic School. He is a trustee of the Fort Worth Museum of Science and History and is involved with Sister Cities International. (Courtesy of Teresa Montes.)

**Pam Minick**

She is called the "Honky-Tonk Woman." Before retiring from her job as marketing director in 2013, Pam Minick was known as the face behind Billy Bob's Texas, the World's Largest Honky-Tonk. The former Women's World Champion Calf Roper rescued the landmark from bankruptcy in 1988 along with her husband, Billy Minick, and other investors. Since then, the 100,000-square-foot entertainment center has shined as the place to go in the stockyards for drinking, dancing, and music. Billy Bob's hosts 120 concerts a year with part-owner Minick, bringing in showstoppers like Garth Brooks, Alan Jackson, and George Strait. She has been inducted into the National Cowgirl Hall of Fame and National Cowboy Hall of Fame, but one of her biggest thrills was meeting Ringo Starr. The music legend would stand at the back door of Billy Bob's and watch the bull riding. "I had to pinch myself," admitted the young retiree who saw hundreds of acts perform at Billy Bob's. "After all, he was a Beatle!" (Courtesy of Pam Minick.)

**O.B. Macaroni Company**
One of the few pasta manufacturers in the United States, the O.B. Macaroni Company opened in 1899 when two Italian grocers, John (Giovanni) Laneri and Louis Bicocchi teamed up to create the Fort Worth Macaroni Company. The business grew and began shipping pasta across Texas. In 1999, O.B. Macaroni, now owned by JGR Enterprises, celebrated its 100th birthday by making pasta donations to 10 food banks. (Courtesy of Doug Sutherland.)

**Doc and Chuckie Hospers**
William "Doc" Hospers and his wife, Charlyn "Chuckie" Hospers, founded the Vintage Flying Museum in 1990 at Fort Worth Meacham Field. Over the years, the museum became known for its collection of vintage aircraft, including a World War II B-17G Flying Fortress. The plane was sold to a military aviation museum in 2011. The Vintage Flying Museum serves as a resource for World War II memorabilia and aviation education programs. (Courtesy of Bill Leader.)

**Windy Ryon**

Windy Ryon, a diehard cowboy and businessman, was the owner of Ryon's Saddle Shop and Western Store in the stockyards district. The retail outlet became a gathering spot for ranch hands and tourists who enjoyed hearing Ryon's tales about the Old West. The Windy Ryon Memorial Roping, named in his honor, is held every Memorial Day weekend and is one of the largest and most respected events on the rodeo circuit. (Courtesy of Joan Kurkowski-Gillen.)

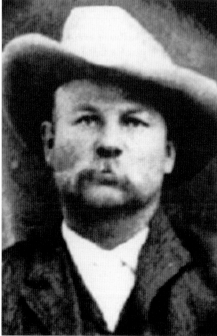

**T.J. Ryon**

T.J. Ryon moved to Fort Worth in the late 1800s and settled on a large ranch where Meacham Airport is now located. An independent cattle trader, he purchased the first herd of cattle arriving at the new Fort Worth Stockyards, according to his descendants.

On March 14, 1908, he also participated in the first indoor cutting horse competition at the Fort Worth Coliseum. (Courtesy of the Ryon family.)

# CHAPTER SIX

# Craftsmen

There is a lot more to Fort Worth than just cowboys and cattle. The city boasts some of the most accomplished actors, athletes, writers, and musicians of today—and yesterday. These skilled craftsmen, featured in this chapter, share their talents and passion with the world, but at some point along their path, Fort Worth has been home, influencing their art.

J'Nell Pate did not need to travel far to find inspiration for her books. The cattle drives and meatpacking industry provided the material for the award-winning *Livestock Legacy: The Fort Worth Stockyards 1887–1987*. She has also written about Carswell Air Force Base and Hazel Vaughn Leigh's work establishing the Fort Worth Boys Club.

The Light Crust Doughboys are mentioned in at least one of Pate's books. Organized in 1931 by the Burrus Mill and Elevator Company in nearby Saginaw, the Western Swing group is the longest-running band in the history of recorded music. Fans still remember watching Bob Wills perform with the group.

Delbert McClinton is another favorite son. The Grammy award–winning singer songwriter was born in Lubbock but moved to Fort Worth when he was 11. His first gigs as a young musician were at the legendary Skyliner Ballroom where he learned from blues masters Jimmy Reed and Howlin' Wolf.

Broadway superstar Betty Buckley still thinks of Fort Worth fondly, continuing to give back to the community. Her range of Broadway appearances is extensive and impressive, yet she began her career on the stages of Tarrant County.

Ashlee Nino may rest her head in California but Fort Worth will always be home. This dance sensation unleashed her talent in Los Angeles, quickly finding jobs dancing with the best—from performing with musicians to dancing on award shows.

Fort Worth's energy and exuberance fuel a craftsman's creativity. From Billy Bob's Texas to the Van Cliburn Piano Competition, it is the place that launched a thousand careers.

### Light Crust Doughboys

"Listen everybody, from near and far if you wanta know who we are. We're the Light Crust Doughboys from Burrus Mill."

Burrus Mill, one of the largest grain elevators in the United States, was known for producing more than Light Crust Flour back in the 1930s. The grain mill also sponsored what became one of the oldest and musically versatile bands in America—the Light Crust Doughboys. The group's history spans more than three-quarters of a century.

Started in 1931 by Bob Wills and Milton Brown (the father of Western swing), the band performed on a radio show that doubled as an advertising vehicle for the grain mill's main product—Light Crust Flour. Future Texas governor W. Lee "Pappy" O'Daniel, who was the general sales manger of Burrus Mill, served as the show's emcee. A large fan base tuned in every day at noon to hear folk and fiddle tunes as well as cowboy ballads and country-and-western songs.

With the start of World War II, Burrus Mills ended the Doughboys' radio show. It resumed in 1946 but never regained the popularity it once enjoyed.

A reinvented Light Crust Doughboys found new fans in the 1960s and are featured on Bob Wills's 1973 album *For the Last Time*, recorded in Dallas.

Under the leadership of Smokey Montgomery, the band found new audiences for its music in later decades. The Light Crust Doughboys were the first inductees into the Texas Western Swing Hall of Fame and, in 1995, were named the "official music ambassadors of the Lone Star State" by the Texas Legislature. Winners of a Grammy award in 2003 for the CD *We Called Him Mr. Gospel Music: The James Blackwood Tribute Album*, they were elected into the Texas Radio Hall of Fame in 2006. Art Greenhaw now leads the band. (Courtesy of Tim Scheer Photography.)

### Red Steagall

A Texas native, Red Steagall wears many hats. He is an author, actor, songwriter, performer, producer, and host. Yet, his cowboy hat still remains his favorite.

He has penned more than 200 songs and recorded 26 albums—all depicting aspects of the Western way of life and faith. Steagall produced the film *Big Bad John* and his television show, *In the Bunkhouse with Red Steagall*. Fans can also find Steagall on the airwaves hosting his syndicated show, *Cowboy Corner*. Each year, the Red Steagall Cowboy Gathering, created by Steagall, lands in Fort Worth to celebrate Western heritage and traditions.

A former chair of the Board of the Academy of Country Music, Steagall has earned numerous accolades. In 2003, he received his greatest honor thus far when he was inducted into the Hall of Great Westerners at the National Cowboy and Western Heritage Museum. (Right, courtesy of Carolyn Cruz; below, courtesy of Vaughan Wilson.)

109

## Don Edwards

There is a reason he is called a cowboy balladeer. Don Edwards's songs paint a picture of life on the range and keep alive the lore and legends of the Old West.

Two anthologies recorded by the Grammy-nominated singer/guitarist, *Guitars & Saddle Songs* and *Songs of the Cowboy*, are in the Folklore Archives of the Library of Congress. He later released them as a 32-song double CD/cassette called *Saddle Songs*. During his three-decade career, Edwards was inducted into the Western Music Association Hall of Fame and received six prestigious Wrangler Awards for Outstanding Traditional Music from the National Cowboy and Western Heritage Museum in Oklahoma City. In 2010, the museum presented him with the Chester A. Reynolds Memorial Award for perpetuating the ideals, history, and heritage of the American West.

A familiar figure in the Fort Worth Stockyards, Edwards is also known for his role as "Smokey" in Robert Redford's hit movie *The Horse Whisperer*. (Courtesy of Scott O'Malley & Associates, LLC.)

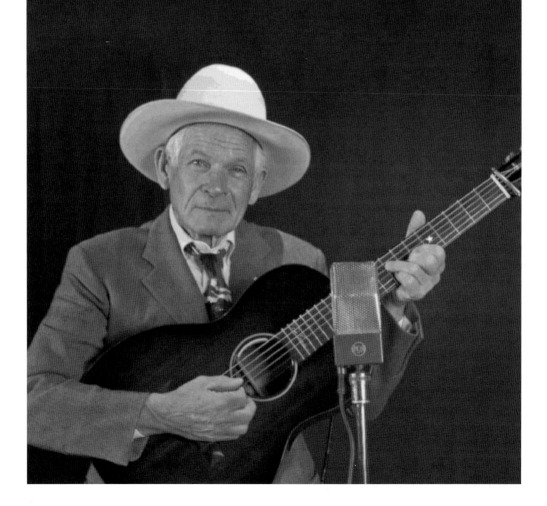

**Richard Selcer, PhD**
Dr. Richard Selcer is an author, professor, and expert in US history, especially the Texas narrative. The source of more than 10 books and many articles, Selcer focuses much of his study and writing on Fort Worth. During his career, he served as professor at numerous Texas colleges. Selcer serves on the board of directors for the Log Cabin Heritage Foundation and is part of the Tarrant County Historical Commission. (Courtesy of Richard Selcer.)

**Joyce Ann Roach**
Three-time Spur Award winner Joyce Ann Roach dedicated her life to writing folklore and nonfiction portraying the Texas life. Roach published books and articles with many receiving recognition and accolade. She also taught in Tarrant County schools and universities. She is a member of numerous organizations such as the Texas Folklore Society, National Cowgirl Hall of Fame, and the Woman's Club of Fort Worth. (Courtesy of Joel Fowler.)

**Tim Madigan**

Tim Madigan was an award-winning journalist long before authoring *I'm Proud of You*, a critically acclaimed book about his friendship with television icon Fred Rogers. The memoir chronicles how the *Fort Worth Star-Telegram* reporter met the creator of *Mr. Roger's Neighborhood* in 1995 and then forged a relationship with the soft-spoken television host. A movie based on *I'm Proud of You* is planned. Madigan's fourth book is titled *Life Among Humans*. (Courtesy of Tim Madigan.)

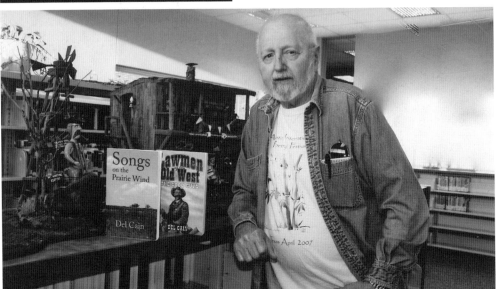

**Del Cain**

Del Cain's celebrates his fascination with the Old West in three nonfiction books, *Lawmen of the Old West: The Good Guys* and *Lawmen of the Old West: The Bad Guys* as well as a collection of poetry, *Songs on the Prairie Wind*. A member of the DFW Writers Workshop, the author is on the Austin International Poetry Festival's board of directors. His stories and poems have appeared in various journals and anthologies. (Courtesy of Joan Kurkowski-Gillen.)

## Dan Jenkins

The "father of modern American sports writing," Dan Jenkins got his start in Fort Worth where he played on the varsity golf team at TCU and shadowed local golf hero Ben Hogan as a cub reporter working for the *Fort Worth Press* and later for the *Dallas Times Herald.*

Over the years, he has written more than 500 articles for *Sports Illustrated*, stories for *Golf Digest*, and several novels. His book, *Semi-Tough*, about a professional football team was made into a movie in 1977 and filmed locally. In 2012, he became the third "scribbler" and first living writer inducted into the World Golf Hall of Fame.

Now retired, Jenkins covered 210 major championships for newspapers and magazines starting with the 1951 Masters and US Open. (Courtesy of World Gold Fall of Fame & Museum.)

**Delbert McClinton**

Singer-songwriter Delbert McClinton's ability to merge country, blues, soul, and rock and roll genres into a distinct musical style is rooted in his Fort Worth upbringing. Born in Lubbock, the Texas legend moved to Cowtown as an 11-year-old and was influenced by the country-and-western bands and blues singers that filled the city's honky-tonks. Years later, he played the guitar and harmonica at bars along Jacksboro Highway where he kept regulars entertained for hours.

In the early 1970s, McClinton and fellow Texan Glen Clark moved to Los Angeles where they cut two albums for Atlantic Records. But it was the mid-1990s before McClinton gained widespread national attention. He won a Grammy for his duet "Good Man, Good Woman" with Bonnie Raitt and released several acclaimed albums including *Nothing Personal*, which earned the musician another Grammy for Best Contemporary Blues Album. After a 40-year break, McClinton reunited with Clark for the 2013 release of new material *Blind, Crippled, and Crazy*.

Over the years, artists like Emmylou Harris, Vince Gill, Wynonna, Garth Brooks, and Trisha Yearwood have recorded covers of his songs. (Courtesy of Stuart Dahne Photography.)

## Ace Cook

A.C. "Ace" Cook wore many hats during his 74 years on earth, but future generations of Texans will remember him as a man who preserved and appreciated some of the best artwork produced by early Texas painters. Cook's hobby of purchasing late-1800s to mid-1900s pieces became known as the Hock Shop Collection. It was sold to Houston businessman John L. Nau after Cook's death in 2010. (Courtesy of Jeff Prince.)

## Nancy Moore

Nancy Moore enjoyed her life married to a prominent Fort Worth lawyer and judge, and her high school sweetheart, Scott Moore. The couple raised five children.

In 1979, Moore turned an old auto station into a gift store that first sold brass pieces. But Moore made a bet on sterling silver's popularity, and Parkhill's Jewelry & Gifts was born. With growing success, Moore then developed a wholesale jewelry business that turned into Barse & Company. (Courtesy of Barse & Company.)

### Ashlee Nino

From her first step, Ashlee Nino, Fort Worth born and raised, danced to her own music. She started dance lessons at age two and blossomed into a talented, passionate, and competitive dancer by age 11. She trained with the Dallas-based BBOY Crew in her teens and landed a position with the Dallas Desperadoes Dancers after graduating high school.

When she moved to California to pursue her dreams, she crashed an audition and scored representation with Bloc Talent Agency. The rest is history.

Nino has worked with artists such as Jennifer Lopez, Christina Aguilera, Cyndi Lauper, and Will Smith. She has appeared on movies, television programs, and awards shows. In addition to her dancing successes, Nino is also an up-and-coming drummer, making a splash in the music scene. (Above, courtesy of Ashlee Nino; left, courtesy of Levi Walker.)

### J'Nell Pate

J'Nell Pate studied journalism at TCU, but it was her postgraduate work in history that whetted an appetite for Fort Worth's colorful past. A prolific researcher, she has authored books on the stockyards, Carswell Air Force Base, and North Fort Worth. Her *Livestock Legacy* won the Coral H. Tullis Award from the Texas State Historical Association. "Fort Worth has a rich history," Pate says. "I feel strongly that it should be written down and preserved." (Courtesy of J'Nell Pate.)

### Janine Turner

Janine Turner is an American actress who is passionate about history and politics. She is best known for her television roles on *Northern Exposure* and Lifetime's *Strong Medicine*. One of show biz's conservative voices, Turner was invited to speak at the Republican National Convention in 2012. She is the author of the bestseller *Holding Her Head High: 12 Single Mothers Who Championed Their Children and Changed History*. (Courtesy of Republican Women of Arlington.)

117

**Barry Corbin**
Best known for his roles in *Northern Exposure* and *Urban Cowboy*, Barry Corbin now calls Fort Worth home. The Texas native studied theater at Texas Tech University and has appeared in *Lonesome Dove*, *The Thorn Birds*, *Fatal Vision*, and *No Country for Old Men*. On television, Corbin played Kyra Sedgewick's father in *The Closer*. The actor suffers from alopecia areata and is now a national spokesperson for the skin disease. (Courtesy of Sandi Love, Elkins Entertainment.)

**Harriet Harris**
It is a long road from Arlington Heights High School to performing on Broadway as the stepmother in *Cinderella*, yet that's the path Harriet Harris trod. She is most known for her television roles as Bebe Glazer (*Frasier*) and Felicia Tilman (*Desperate Housewives*), but Harris's career spans decades of movie and television credits and Broadway appearances. In 2002, Harris won a Tony Award for her role in *Thoroughly Modern Millie*. (Courtesy of Carol Rosegg.)

### Henrietta Milan

Before she began painting, Henrietta Milan was a talented gymnast headed to the 1960 Rome Olympics. She never competed in the games, but her artistry with a paintbrush has flourished. Milan has 19 fine art reproductions and a sold-out limited-edition print to her credit. Her work was featured on the cover of *Fine Art Magazine*. Milan, her husband, Jerry (pictured), and her children opened the Milan Art Gallery in Fort Worth's Sundance Square 21 years ago. (Courtesy of Talon Milan.)

### B.W. Aston

Longtime faculty member of Hardin-Simmons University (HSU), B.W. Aston wrote numerous books focusing on Mexican and Texas history. Aston, a Fort Worth native, also served in many capacities at HSU, most notably dean of the College of Liberal Arts (2000–2001). He traveled the world pursuing his love of history, but while at home, he served many organizations, such as the Texas Folklore Society and the West Texas Historical Association. (Courtesy of Hardin-Simmons University Archives.)

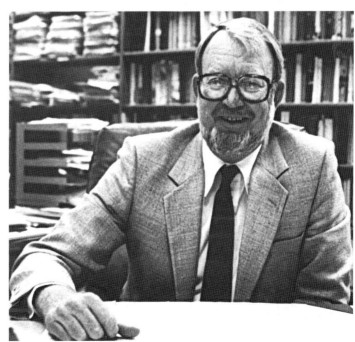

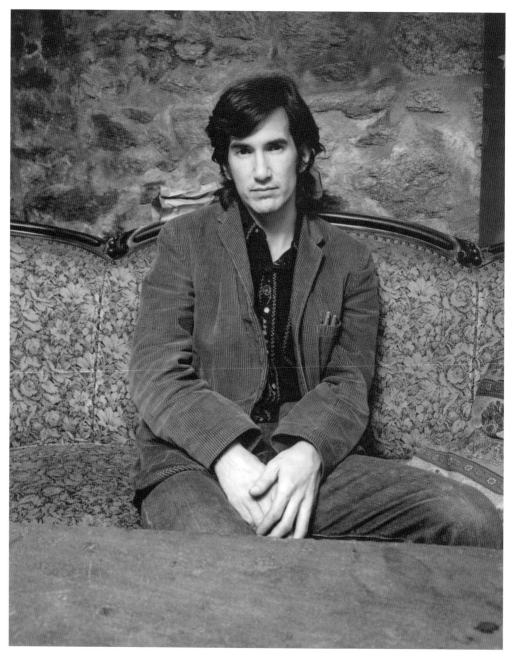

**Townes Van Zandt**
The great-grandson of Khleber M. Van Zandt, Townes Van Zandt is an acclaimed country and folk singer/songwriter. Although much of his music never succeeded in mainstream radio during his life, numerous artists have covered his songs, turning several into hits. Years of substance abuse and struggles with mental illness claimed Van Zandt's life abruptly and too soon. He was a rebel of sorts, bringing soulful sadness through his melodies and lyrics. Omnivore Recordings, in efforts to reintroduce Van Zandt to a modern audience, reissued *High, Low and in Between* and *The Late Great Townes Van Zandt* in 2013. (Courtesy of Steve Salmieri and Omnivore Recordings.)

### Sweetie Ladd

Sweetie Ladd is considered Fort Worth's version of renowned folk artist Grandma Moses.

Although not a native of Fort Worth, the longtime resident used her distinct painting style to preserve the city's historic landmarks and events in watercolors and lithographs. A sophisticated, well-traveled woman, Ladd was a charter member of the Woman's Club of Fort Worth and Fort Worth Garden Club. She began painting at the age of 60 and honed her skills with help from instructors Bror Utter and Frederic Taubes. Praising the primitive look of her work, Taubes encouraged Ladd to stop taking classes and simply paint what she remembered.

Heeding his advice, Ladd captured the Fort Worth of yesteryear. Using the Fort Worth Public Library as a resource, Ladd often recreated scenes from the library's collection of historic photographs. The artist made the landmarks come to life with the interesting placement of people, animals, and other details characteristic of the time period. Many of the places featured in her 28-painting Landmark Series no longer exist.

Describing her own work as "eclectic primitive," Ladd lived long enough to earn recognition from art critics. Her portrayal of a 1908 schoolhouse picnic at the original Broadway Presbyterian Church was chosen for the "American Painters in Paris" exhibition in 1976 held in France to observe America's bicentennial.

Sweetie Ladd's paintings were also celebrated during a sold-out one-person show at Ron Hall's Sundance Gallery in 1982.

Ladd continued to ply her craft until she could no longer hold a paintbrush. She died at age 89.

The book *Sweetie Ladd's Historic Fort Worth* by Ladd and Cissy Stewart Lale chronicles the artist's personal history and the story behind her paintings. (Courtesy of TCU Press.)

## Van Cliburn

He was first a prodigy and then a master pianist. But Van Cliburn, Fort Worth's most celebrated citizen, is credited with more than just entertaining audiences with his musical artistry. A May 1958 *Time* magazine cover story called the musician "the Texan Who Conquered Russia," and few argue the claim. At the age of 23, Cliburn won the first Tchaikovsky International Competition in Moscow at the height of the Cold War. His prize-winning performance earned him an eight-minute standing ovation from the Russians and helped tear down cultural barriers between the United States and Soviets.

After his historic victory, the pianist became the only classical musician honored with a ticker-tape parade in New York City. During his life, Cliburn traveled the world performing at sold out concerts and recording his music. His *Tchaikovsky: First Piano Concerto* was the first classical recording to receive a platinum record for sales.

In 1962, the first Van Cliburn International Piano Competition was held in Fort Worth to encourage the development of young artists. A tribute to the cultural icon, the premier musical event continues to attract musicians from around the world.

The Juilliard-trained musician performed for every president of the United States since Harry Truman and for royalty and heads of state in Europe, Asia, and South America. He received Kennedy Center Honors and the Grammy Lifetime Achievement Award. In a 2004 Kremlin ceremony, he received the Order of Friendship from Russia president Vladimir Putin, and in 2003, Pres. George W. Bush presented him with the Presidential Medal of Freedom. Pres. Barack Obama honored Cliburn with the National Medal of Arts in a ceremony at the White House in 2011. (Courtesy of the Van Cliburn Foundation.)

**Betty Buckley**

Known as the "Voice of Broadway," Betty Buckley is a modern-day legend. She has garnered acclaim on and off Broadway and won several awards, including a Tony for her performance in *Cats*. Her movie credits consist of *The Happening, Tender Mercies, Frantic, Another Woman,* and *Carrie*. She also appeared in numerous television shows, two of which—*Bobby and Sarah* and *Taking a Stand*—earned her Emmy nominations.

In addition to her stage and film projects, Buckley successfully has released nearly 20 recordings. She received a 2002 Grammy nomination for *Stars and the Moon, Betty Buckley Live at the Donmar,* and a second nomination for the audio book *The Diaries of Adam and Eve*.

Yet, with all her achievements in the Big Apple and beyond, Buckley still loves her Texas roots. She performed at the Dallas Theatre Center in 2011 as costar in *Arsenic and Old Lace*. She also taught at the University of Texas at Arlington and in other schools in Fort Worth.

In 2007, Buckley was inducted to the Texas Film Hall of Fame; two years later, she received the Texas Medal of the Arts Award in Theater. (Courtesy of Scogin Mayo.)

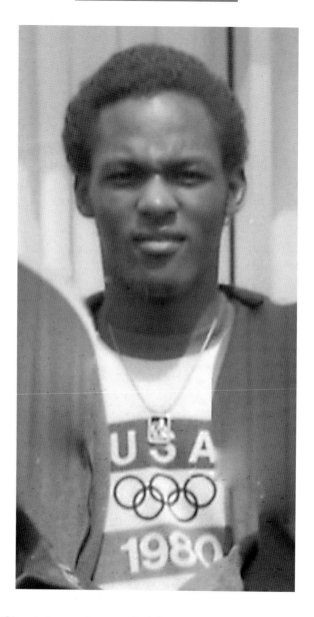

**Donald Curry**

Donald Curry is an Olympic boxer who never had the opportunity to "go for the gold." He earned a welterweight spot on the team by defeating future world junior middleweight champion Davey Moore. When the United States boycotted the 1980 Olympic Games in Moscow for political reasons, the Fort Worth native lost his opportunity to compete for a medal.

But Curry made his mark in the boxing world in other ways. Known as the "Lone Star Cobra," he achieved both amateur and professional success in the ring, winning the North American Boxing Federation, United States Amateur Boxing Federation, and World Boxing Association welterweight titles. During his mercurial 17-year prizefighting career, he was known as a skillful technician who could both box and punch. His professional record of 34-6 includes 25 knockouts.

Curry once told a sportswriter the highlight of his career was winning his first world championship in Fort Worth against Jun Suk Hwang.

Curry now helps train amateur boxers. (Courtesy of the United States Olympic Committee.)

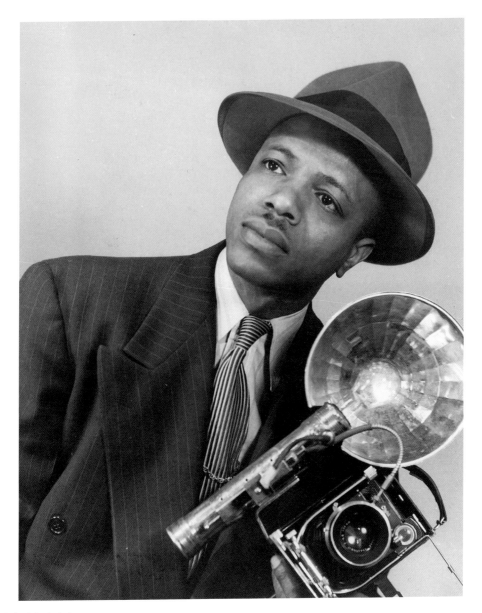

**Calvin Littlejohn**

In 1934, Calvin Littlejohn opened his Fort Worth commercial photography business. During his 50-year career in the studio, as a freelance photojournalist, and as a contract photographer for the FWISD, Littlejohn captured countless aspects of Fort Worth history.

His work also serves as the most comprehensive documentation of urban Texas African American life and culture during the 1940s through the 1980s.

Littlejohn photographed three US presidents, Dr. Martin Luther King Jr., and numerous other public figures and celebrities, such as Ella Fitzgerald and Jackie Robinson.

The artist and businessman's collective work—representing 80,000 pictures—can be found in the Calvin Littlejohn Photographic Archive at the Center for American History in Austin, Texas. (Courtesy of Ron Abram of the Calvin Littlejohn Estate and the Briscoe Center for American History, University of Texas at Austin.)

# INDEX

Find more books like this at
**www.legendarylocals.com**

Discover more local and regional history books at
**www.arcadiapublishing.com**